IMAGES
of America

THE EAGLE RIVER VALLEY

May the past guide
our future -
Shirley Welch

IMAGES
of America

THE EAGLE RIVER VALLEY

Shirley Welch and
the Eagle County Historical Society

ARCADIA
PUBLISHING

Published by Arcadia Publishing
Charleston SC, Chicago IL, Portsmouth NH, San Francisco CA

Printed in the United States of America

Library of Congress Catalog Card Number: 2007941886

For all general information contact Arcadia Publishing at:
Telephone 843-853-2070
Fax 843-853-0044
E-mail sales@arcadiapublishing.com
For customer service and orders:
Toll-Free 1-888-313-2665

Visit us on the Internet at www.arcadiapublishing.com

*To Frank Doll, Mauri Nottingham, and Bill Burnett,
men who knew how it all began.*

CONTENTS

ACKNOWLEDGMENTS

The path that led me to compiling this book had many twists and turns. I have written fiction for many years and have had one book published. During my 40 years of life along the Eagle River, I have prowled graveyards and old mining camps, sometimes getting lost and yet finding my way. Several years ago, I joined our hospice association and began to write "Living Histories" for the appropriate patients. Then I met Frank Doll. As a professional storyteller for over 16 years at the Hyatt Hotel in Beaver Creek, Frank always had a yarn to tell. I worked with Frank for months on his Living History and we became friends. Frank's forefathers were some of the Eagle River Valley's earliest settlers. Books have been written about Vail and Beaver Creek, but the early pioneers were largely forgotten. Thanks to Frank and through this book, I have had the opportunity to re-create the early times along the Eagle River and chronicle some of its history.

Thank you to Jaci Spuhler and Mike Johnson at the Eagle Valley Library District for their dedicated work in scanning the photographs. A special thank-you is due to the Eagle Library and Jaci for her time, the use of the library's equipment, and the archival storage of the photographs. Thank you to the Eagle County Historical Society for allowing me to use their photographs for this work. Thanks to Bill Burnett, who taught me about the ice ponds at Pando and how it all worked. Thank you to Mauri Nottingham, who finally straightened out the Nottingham family tree for me and also clarified some of Frank's stories.

Unless otherwise stated, the photographs in this collection came from the Eagle County Historical Society and Shirley Welch.

INTRODUCTION

As far back as 8,000 years, archaic humans—called hunter-gatherers—roamed the Eagle River Valley, but their remains are scarce. When they disappeared, new people took their place. They were called Ute Indians, and in turn, they called the mountains and valleys *paba-qa-ka-vi*, the Shining Mountains, and they named one watercourse the Eagle River for the great birds that nested in stately evergreen trees lining the riverbanks. In 1540, the first Spaniard who traveled through Colorado was Don Francisco Vasquez de Coronado. Searching for Cibola, the fabled seven cities of gold, he did not find it, but rumors abound that his group first entered the Eagle River Valley and saw the Mount of the Holy Cross. When Coronado returned empty handed, Spanish exploration of the area ended for a while. It began again in 1579, but no mention was made of the Eagle River Valley.

During the 1830s, fur trapping and trading began in western Colorado. Trappers such as Thomas L. "Peg-Leg" Smith, Mark Head, and Jim Bridger worked the Eagle River. The mountain men tramped the area, trapping beaver for fashionable top hats, which were in great demand on the Eastern Seaboard. Those early mountain men ventured west from the Mississippi River, following the streams that the beavers worked. As the hunters decimated the beaver in the streams along the plains, they ventured farther and farther west, moving into the mountains to find more beaver. Once in the mountains, they discovered many streams clogged with beaver ponds, and they also found the Ute Indians, a friendly tribe and happy to trade with skins for goods they could not provide for themselves. The 1830s saw the era of rendezvous, a series of central collection where the trappers would meet to exchange furs and supplies. It came to an end with the advent of the trading post.

Western Colorado remained largely unexplored until John C. Fremont led an expedition from Independence, Missouri, to Bent's Fort and hired Kit Carson as a guide. The men ventured along the Arkansas Valley, over the Continental Divide at Tennessee Pass, and followed the Eagle River to the Grand (Colorado) River. These early explorers passed what were to become Gilman, Minturn, Avon, Edwards, Eagle, and Gypsum. In 1846, the Mexican war began and put a stop to exploration in the western United States. When the war ended in 1848, exploration began again and some private explorers entered the area. Sir St. George Gore arrived from Ireland with a host of servants and lavish goods. The Gore Range and Gore Creek were named after him. In the 1860s and 1870s, prospectors worked the Eagle River looking for gold, but the prospects were dim. Starting in 1873, Ferdinand Vandiveer Hayden began his survey of Colorado and brought with him William Jackson, who captured on film the Mount of the Holy Cross, a majestic peak that overlooks the Eagle River Valley.

In the early 19th century, the Ute occupied western Colorado and eastern Utah. They were fierce, nomadic warriors who mastered the art of horsemanship. After attacking Mexican settlements in the San Luis Valley of Colorado, the Ute were subdued and a treaty signed. In 1868, they were placed on a large reservation in Colorado, but some strayed from the reservation. New silver and gold discoveries along tributaries of the Eagle River brought increased tensions with the Ute

Indians. In 1878, Nathan Meeker was appointed agent for the White River Agency. Because Meeker did not understand the concept of a nomadic tribe, he proposed that the Ute become farmers. The Ute rebelled at this idea. Thus began a clash of cultures. In 1879, Meeker and 10 men were massacred by Chief Ouray's brother-in-law and others. This act gave people the excuse to demand the removal of the Native Americans from the Rocky Mountain area. The government was successful with this directive, and in 1881, the Ute left Colorado, taking up residence in Utah. With the Native Americans removed, the Eagle River Valley was open to all.

With the Native American threat gone, mining activity increased and hunters traveled farther along the Eagle River Valley, where they discovered ample game, fish, and ground so fertile that anything would grow. Those who chose not to work in the mines ventured into ranching and farming. Still the Eagle River Valley was a difficult area to reach, with only stock trails in place. In the winter, hand sleds were used and toll roads installed.

In 1882, the Denver and Rio Grande Railroad reached Red Cliff and the future of the valley changed forever. More people settled in the valley, and towns were built: Gilman, Minturn, Avon, Edwards, Wolcott, Eagle, Gypsum, and Dotsero. As always, the river carried the spark of life for each generation of fortune seekers, whether it was mining or the railroad or farming. The miners needed the water for their stamp mills. The railroad needed water to feed the steam engines. The farmers needed to irrigate their lettuce fields. The ranchers had to water their stock. Toward the beginning of World War II, Pando was chosen as the place to build Camp Hale, a facility for training troops in skiing and winter warfare. Seemingly overnight, a vacant valley at close to 10,000 feet in elevation became the home to more than 16,000 soldiers. The infamous 10th Mountain Division took part in the war in Italy. Several of those men in the 10th Mountain Division returned to Colorado after the war and founded Vail and Beaver Creek ski areas. Soon skiers replaced the lettuce fields and mines. Those early developers of the ski resorts were equally as adventuresome and resilient as the Eagle River Valley's first explorers. Today Vail and Beaver Creek mountains are host to over 2.5 million skiers a year.

Water that starts as a trickle up on Tennessee Pass still flows down through the canyons and valleys, ensuring that life along the Eagle River Valley will continue into the future.

One

PANDO AND CAMP HALE

Emerging from the west side of the Continental Divide on Tennessee Pass, the Eagle River begins where the East Fork and South Fork meet in a glacial valley. When the Denver and Rio Grande Railroad arrived in 1882, the rail station was named Pando. For many years, the area lay vacant, but in the early 1900s, as the lettuce, potato, and pea crops became profitable in the lower valleys, Pando became the mecca for ice production.

When the lettuce crops grew brown rot and the Depression hit, that was the end of the need for ice. For a while, Pando remained quiet, but soon the U.S. military decided it needed a place to provide winter warfare training during World War II. Pando was chosen for that purpose because it was suitable for training in skiing, rock climbing, and cold weather survival skills.

To build Camp Hale, the swamp-like conditions of the area needed to be mitigated. Thus the Eagle River was rechanneled into a straight line to provide drainage of the valley.

By the time the construction of Camp Hale was completed, some 40,000 workers were involved. The camp now provided mess halls, barracks, a hospital, a chapel, a fire station, administration buildings, and facilities for the mules. Recreational needs of the troopers included an 18,000-square-foot field house, service clubs, and an auditorium.

Ready access to the camp was provided by the Denver and Rio Grande Railroad and Highway 24, while new water wells were needed for up to 16,000 personnel in training. After World War II, the Central Intelligence Agency trained Tibetan soldiers at the camp. In July 1965, Camp Hale was deactivated and control of the lands returned to the forest service in 1966. All of the buildings at Camp Hale were torn down.

Military use of the Camp Hale included the 10th Mountain Division. After the war, several soldiers who trained at Camp Hale returned to Colorado and developed Vail and Beaver Creek ski areas.

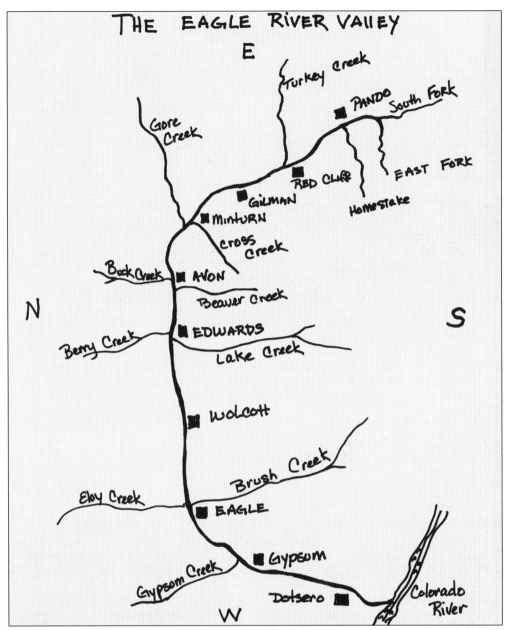

The Eagle River Valley lies in central Colorado. It flows from east to west. Starting at the top of the Continental Divide, it ends nearly 70 miles later when the Eagle River flows into the Colorado River at Dotsero. Along the way, the elevation drop of the valley is nearly 2,000 feet. The Eagle River Valley is made up of the towns of Red Cliff, Gilman, Minturn, Avon, Edwards, Eagle, and Gypsum. The tributaries of Homestake Creek, Turkey Creek, Gore Creek, Cross Creek, Beaver Creek, Lake Creek, Squaw Creek, Brush Creek, Eby Creek, and Gypsum Creek all join the Eagle River along its route. Starting as a trickle deep in rock, the river that forms the Eagle Valley broadens as it continues its journey until it ends in a wide, soil-rich plain just before it enters a deep gorge called Glenwood Canyon.

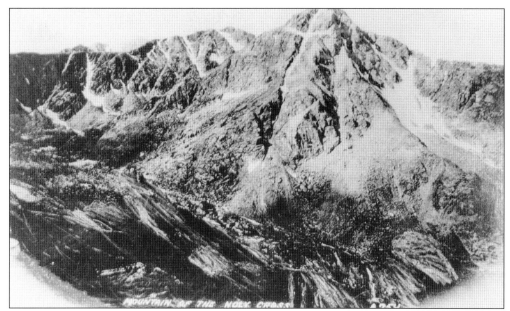

In 1873, the great Hayden Surveys of Colorado began. Ferdinand Vandiveer Hayden, a professor of medicine from Yale University, was selected to lead surveys throughout western Colorado. Hayden brought geologists, botanists, topographers, and a photographer, William Henry Jackson. In August of that year, Jackson photographed the Mount of the Holy Cross, a 14,000-foot peak in the Sawatch Range, which features a crevasse that forms a cross of snow.

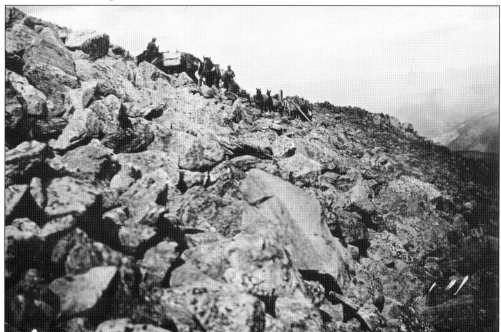

A pack train hauls supplies up the trail to Notch Mountain. From Notch Mountain, a spectacular view of Mountain of the Holy Cross can be seen. Hundreds of people yearly make the pilgrimage to view the cross from Notch Mountain. In 1934, a shelter house was built to give refuge to those making the arduous trek.

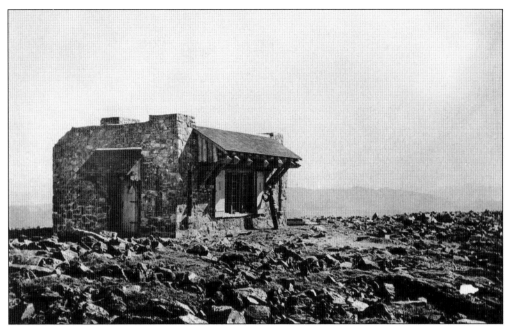

Once completed, the rock shelter house became a sentinel to Mount of the Holy Cross. The shelter house was made of rock and stone and was built to withstand extreme temperature changes. Today many enthusiasts climb Notch Mountain and stop at the shelter house to view the cross of snow.

Before 1879, there was no record of a wheeled vehicle entering the Eagle River Valley. In 1880, the Denver and Rio Grande Railroad reached Leadville. The impact of the railroad being built through Colorado and the Continental Divide would change the area dramatically. The first station in the Eagle River Valley was the depot at Pando.

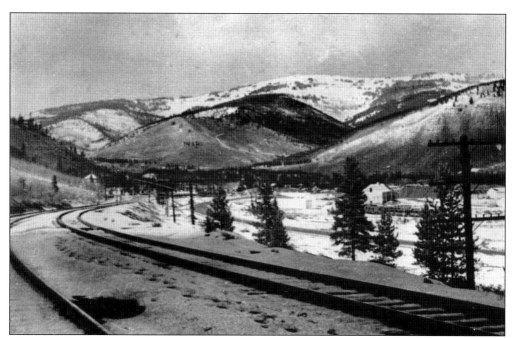

This photograph shows the level stretch of rails through Camp Hale. Stations down Tennessee Pass were named Tennessee Pass, Mitchell, Eagle City, Eagle Canon, and Red Cliff. Eighty-five Native Americans worked the project. They lived in railroad cars and stayed on the job full-time.

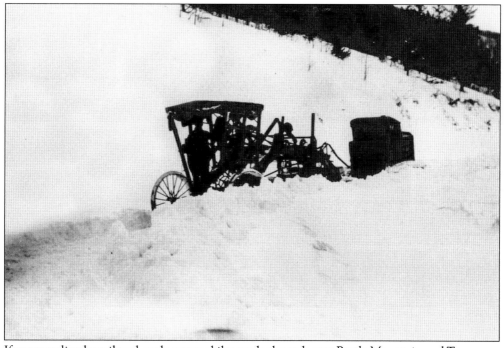

If not traveling by railroad, early automobiles made the trek over Battle Mountain and Tennessee Pass. With no guard rails and a dangerous drop to the canyon below, the trip could be heart-stopping, and with over 163.5 inches of annual snowfall, maintenance crews worked long hours on snow removal.

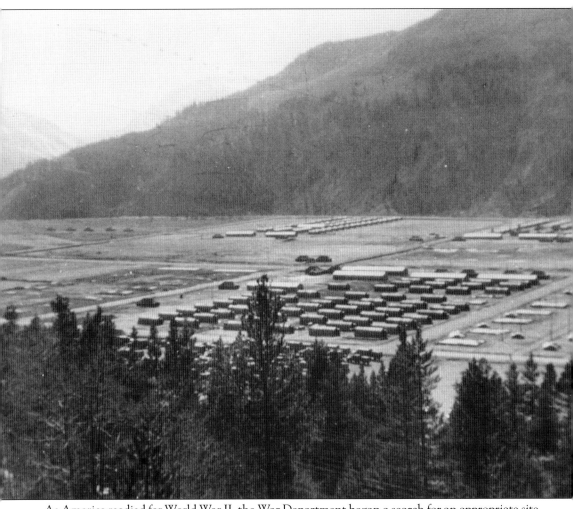

As America readied for World War II, the War Department began a search for an appropriate site for training troops in skiing and winter warfare. The area around Pando was chosen. Construction began. The East Fork Valley was cleared of swampy conditions. With the river rechanneled, the camp spread across the wide valley. Highway 24 was moved from the north side of the valley to

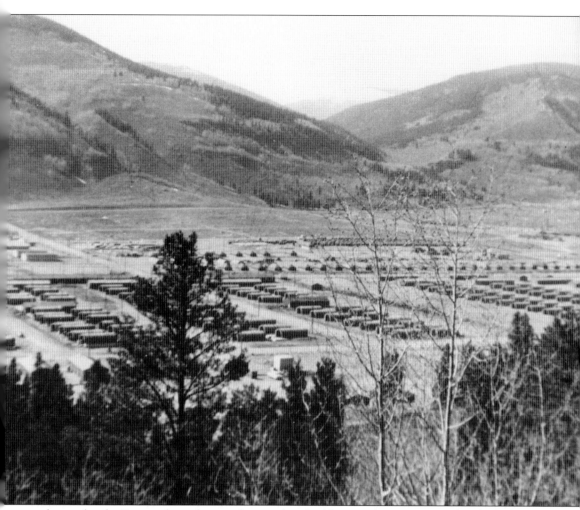

the south side. During the eight months it took to build, more than 40,000 workers had a hand in construction. During its tenure, Camp Hale was home to more than 18,000 soldiers. After World War II, from 1959 to 1964, Tibetan guerillas were trained at the camp by the CIA. The site was chosen by the CIA because of the similarities to the Himalayan Plateau.

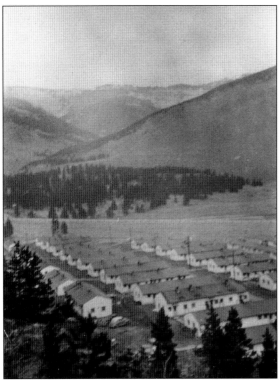

Named in honor of Spanish-American War general Irving Hale, the camp varied between 5,000 and 247,243 acres during the time it was an active military installation. Military use of Camp Hale included the 10th Mountain Division, the 38th Regimental Combat Team, 99th Infantry Battalion, and soldiers from Fort Carson.

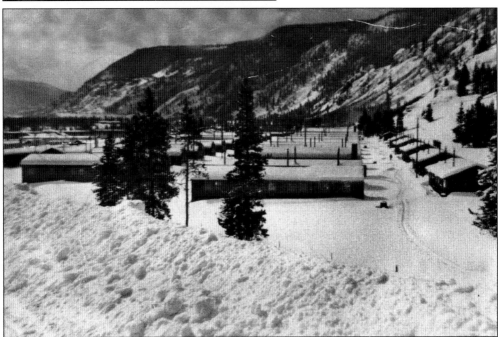

In the wintertime, the snow depths nearly reached the windows on the barracks. Coal heated the buildings and created a dense dark cloud over the valley, the only detriment to Colorado's crystal-blue skies. Besides mountain warfare training, the army tested a variety of weapons and equipment at Camp Hale.

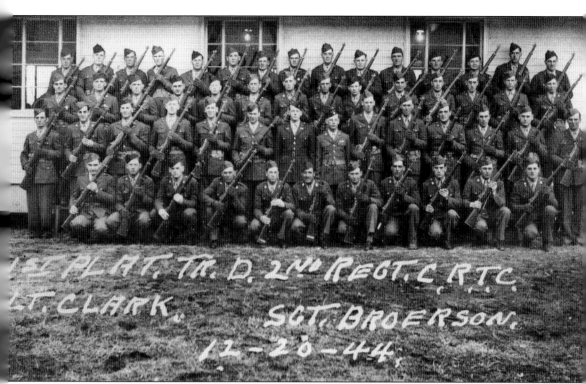

Of the 18,000 men who trained at Camp Hale, approximately 16,000 soldiers were members of the 10th Mountain Division. In this photograph is the 1st Platoon, 2nd Regiment with Sergeant Broerson and Lt. Earl Clark at Camp Hale in December 1944. Lieutenant Clark was a supervisor of military ski training, and he greatly improved his skills by skiing with some of the greatest skiers in the world. After leaving the military, Earl Clark worked with several different ski area ski patrols including Arapahoe Basin, Loveland, Berthod Pass, and Winter Park. He formed the National Association of the 10th Mountain Division, became its first national president, and held the office for seven years. In 2001, Earl Clark was inducted into the Colorado Ski Hall of Fame. Many other members of the 10th Mountain Division played a notable part in the development of ski areas in America.

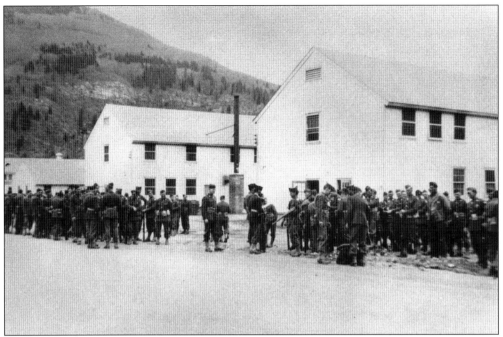

The 10th Mountain Division was deployed to Europe in December 1944. In February, a battalion of the 10th Mountain Division arrived in Italy and made a treacherous climb up sheer rock cliffs that lead to German observations positions on Riva Ridge. To reach the summit where the Germans were entrenched required climbs from 1,500 to 2,200 feet, done at night under the cover of darkness.

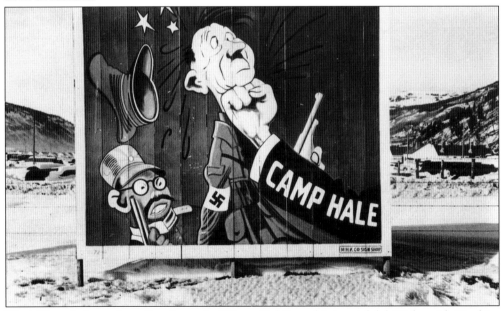

The billboard along a fence line shows the "Camp Hale" arm hitting Adolph Hitler with Hirohito watching. Behind the billboard are the rows of barracks. Soldiers also learned to drive jeeps off-road, and as a campaign to sell war bonds, the soldiers offered free jeep rides to anyone who invested in the war effort.

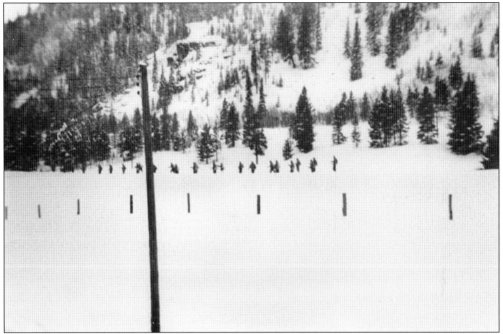

Training in high elevation and frigid temperatures conditioned the troopers for what they would encounter in Europe. Thousands of soldiers hiked to altitudes of 13,000 feet and spent three weeks deployed with war games. Those soldiers who could ski taught those who could not. All became competent on skis.

Near Camp Hale, Cooper Hill was developed with 10 runs and four rope tows. Today the area is still in operation. When the war ended, the word-of-mouth advertising by GIs trained in Colorado did more to revitalize tourism than any marketing plan implemented at the time. Pete Siebert enlisted his good friend Earl Eaton to find a ski area to build, and in 1962, Vail ski area opened.

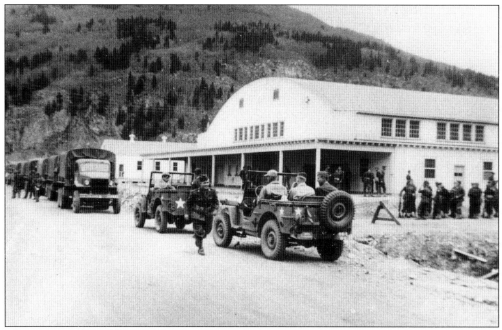

The Camp Hale Field House was 18,000 square feet. It had to be built to hold the snow loads common to Pando in the wintertime. For other recreation opportunities, Leadville was the closest town, although the War Department thought the town was lacking in appropriate social and recreational amenities for the soldiers.

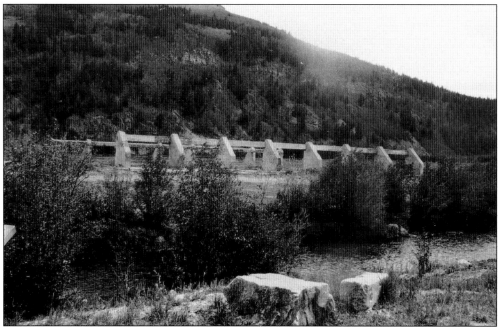

Today all that remains of the field house are the cement ramparts. It is an eerie sensation to drive along the dirt roads of Camp Hale in the 21st century. Row after row of cement pads are silent reminders that once a mighty army was housed in the barracks. The river, once a snaking spiral of water and swampy meadow, now flows in a straight line.

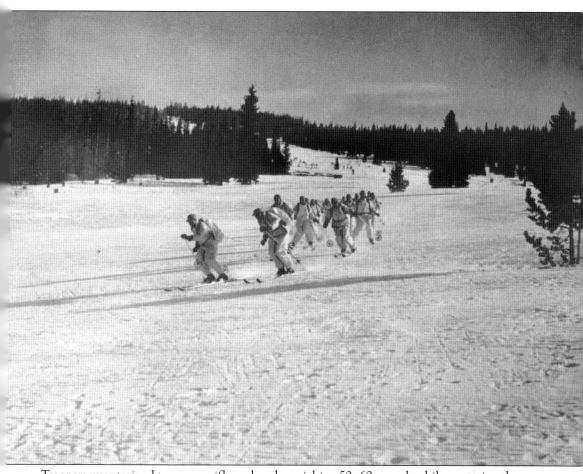

Troopers were trained to carry a rifle and packs weighing 50–60 pounds while mastering the art of skiing. Besides downhill skiing, the troopers trained in rock climbing, cross-country skiing, and cold weather survival skills. With an annual snowfall of 163.5 inches, winter weather conditions were guaranteed. With so much snowfall, additional modifications of structural designs for the cantonment buildings were needed. Besides structural changes, five additional water wells were built to meet the needs of the soldiers. Camp Hale included training on a rifle and pistol range and grenade and bayonet courts. Some troopers discovered the love of skiing, and it stayed with them their entire lives. The 10th Mountain Division trained at Camp Hale in the winter of 1943–1944. In January 1945, they were deployed to Italy to roust the Germans from the Italian Alps. After scaling River Ridge, they surprised the Germans and took the mountain. That victory enabled them to continue to the Po Valley and help win the war.

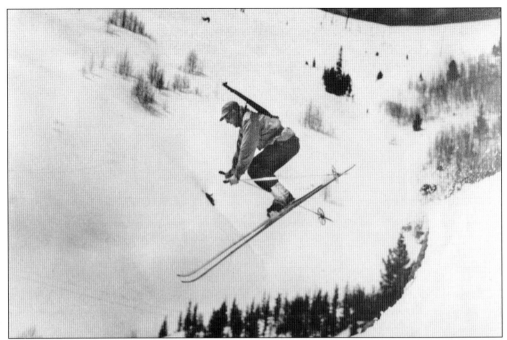

North of Camp Hale lay steep open bowls, backed by the dramatic profile of the Mount of the Holy Cross. The open bowls were created during fires in 1879. Rumors speculate that the Ute Indians set the fires to drive the whites from the area. Most likely the fires were natural, following a dry period.

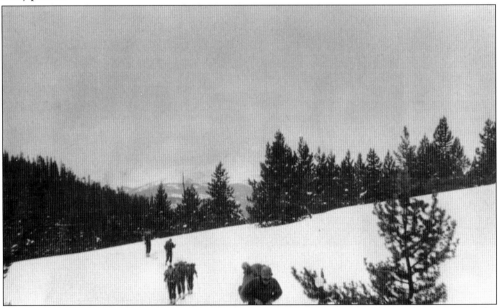

In July 1943, assistant agriculture secretary Grover B. Hill opened up thousands of acres to the War Department. Hill authorized the War Department to use all the national forest lands in the area around Camp Hale for military training and such other purposes as the department felt necessary to further the war effort. Some 14,000 soldiers trained in the 10th Mountain Division at Camp Hale.

Pete Seibert—a member of the 10th Mountain Division—returned from Italy after being severely injured. After forming an investment company called the Transmontane Rod and Gun Club, he and Earl Eaton, Bob Fowler, and John Conway quietly began to purchase land along Gore Creek. Today Vail is an incorporated town and one of the world's foremost ski areas.

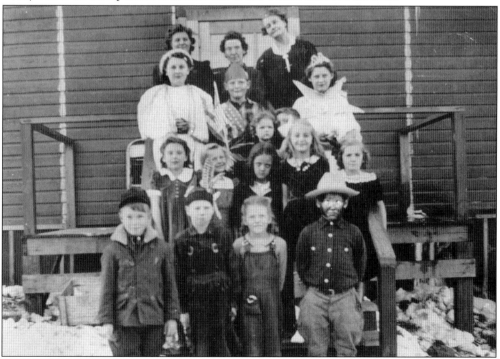

Schoolchildren line up in front of the Camp Hale School in Pando in the 1940s. With so many construction workers feverishly trying to complete Camp Hale in a record six months' time, the influx of workers and their families was huge. Besides school, children enjoyed sledding and skating on the ice pond at Pando.

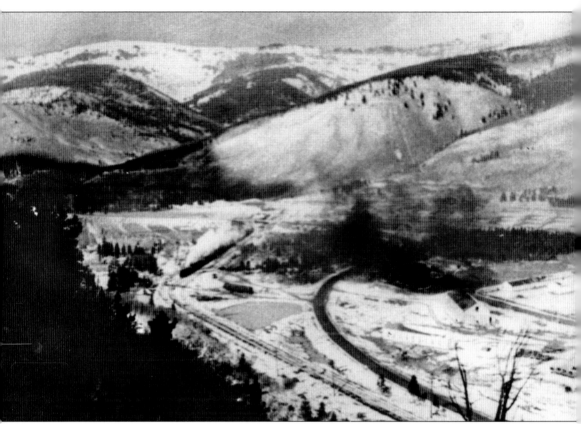

Camp Hale became the home of more than 16,000 soldiers. The black smudge in this photograph is a testament to the coal that was burned to heat the buildings at the camp. Air inversions held the smoke and particulates over the camp in a continuous black cloud. Another difficulty to overcome at the camp was the wartime copper shortage that affected the design of the electrical systems. Social requirements had to be addressed as well. Before the army would allow soldiers into Leadville, the city council and police had to clean up the town by enforcing gambling and liquor laws. The morals of some of the women in town also required attention, and this too was addressed with some success. After the cleanup, Leadville benefited from the new military base.

Two

THE MINING
COMMUNITIES

In 1878, news spread of a bonanza of lead carbonates on Battle Mountain. A stampede of miners flooded the area, swarming over the area where Turkey and Homestake Creeks flowed into the Eagle River. These miners established the camps of Red Cliff and Gilman. Up along the Homestake drainage, Gold Park, Holy Cross City, Missouri Camp, and Camp Fancy sprang up.

In 1868, the Ute had been placed on a large reservation in Colorado. In 1878, Nathan C. Meeker was appointed the Indian agent for the area. Meeker urged the Ute to become farmers. The Ute revolted at his demands, and he was massacred. Fearful of more hostility, Red Cliff residents built a fort at the junction of Turkey Creek and the Eagle River. Serious repercussions were avoided through the peaceful efforts of Chief Ouray. After the Meeker Massacre, the Ute were moved to reservations in western Colorado and Utah. Without the threat of the Ute Indians, more settlers arrived.

Although gold and silver mines diminished, mining continued on Battle Mountain. When the gold strikes ended, the miners on Battle Mountain led directly to the discovery of zinc, silver, and copper ore.

At first, prospectors lived in Red Cliff, but the three-mile jaunt to the mines was too far, so a camp was established on the cliffs above the Eagle River, which was called Rock Creek. A post office there was given the name Clinton but quickly changed to Gilman when it conflicted with another town called Clinton in California. Gilman was named after Henry Gilman, superintendent of the Iron Mask Mine. By 1890, Gilman had surpassed Red Cliff in population.

Eventually the New Jersey Zinc Company owned the Eagle Mine on Battle Mountain. For many years, the mine employed most of the people in the area. The mine shut down in 1981. Today Gilman is a ghost town. However, another prospector has purchased the mine and has proposed building a new ski resort on top of Battle Mountain.

Today the Homestake Dam reroutes water headed for the Eagle River to the Front Range. For all the wealth created from mining operations, the revenue from the water will produce more millions than all the wealth created by mining gold, silver, or zinc.

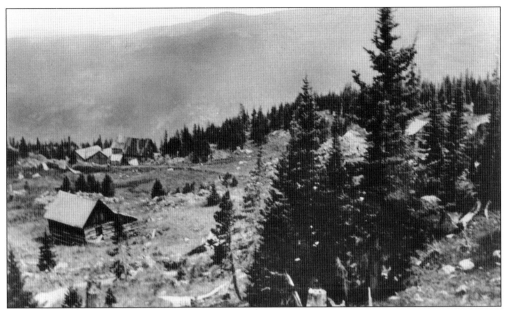

On the east side of French Mountain in the Homestake Valley, Holy Cross City was built on a marshy flat below the major mines, "Little Mollie" and "Grand Trunk." In 1881, the town had a post office, a general merchandise store, an assayer, a justice of the peace, and a boardinghouse. By 1890, the only business in town was McNeeley's Gold Stamp Mill.

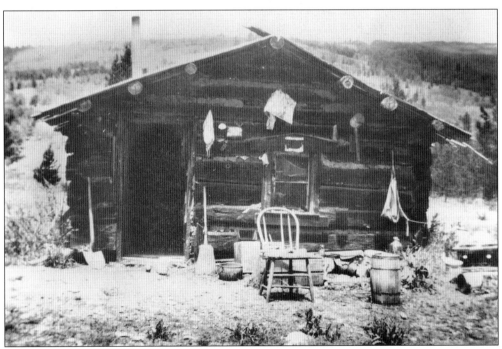

The Walter Hyde cabin rests in Gold Park. This mining district was in operation from 1880 to 1883 and was located on the valley floor, which was a fine resting spot for those going on to Holy Cross City. By 1881, the camp had a population of 400 and boasted a post office and two hotels. A daily stage traveled to Red Cliff.

This prominent outcropping sits at the confluence of Turkey Creek and the Eagle River and is called Lover's Leap. Legend has it that a Ute Indian chief's son loved a woman who was deemed unsuitable as a bride, and the two were refused permission to marry. Instead of separating, the lovers jumped off the top of the cliff and lived forever together in the next world. The Ute Indians were the primary inhabitants of west-central Colorado. Seldom forming groups of more than 100, they were able hunters and feared warriors, and when the Spanish introduced the horse, it allowed the Ute to increase their effectiveness as hunters. It also increased their range of mobility. The Ute reached their height of power in 1750. As of 1990, there were over 7,500 Ute in the United States.

In 1879, the first cabin was built in Red Cliff by William Greiner and G. J. Dalee. In anticipation of a gold rush, Robert L. Rohm and partners staked out the town of Red Cliff. The town was the first permanent settlement along the Eagle River. Before the Ute problem was solved, the population of the town dwindled, but by spring of 1880, the population had increased enough to rival Leadville in population. In 1880, the town was incorporated and the first sawmill was established, which brought a building boom. However, the building boom resulted in oversupply of houses. In the winter of 1881–1882, many homes stood empty. With the mushrooming expansion of the town, Red Cliff suffered from disastrous fires. In 1882 and 1883, fires destroyed several buildings. Although a water system was completed in the town in 1887, in 1889 half the town was destroyed by fire.

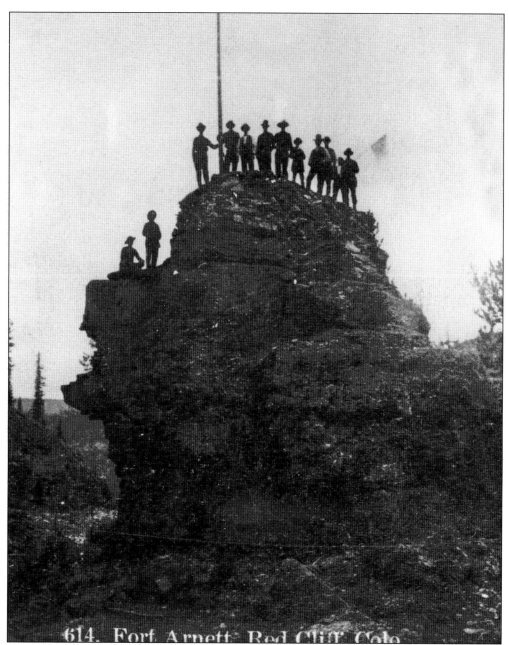

614. Fort Arnett Red Cliff Colo.

In 1878, the White River Agency in northwestern Colorado appointed Nathan C. Meeker as head of the Indian agency. He proved to be the wrong man for the job. Meeker tried to convert the nomadic Ute Indians to farmers, and the effort incensed the natives. Tensions rose between Meeker and several bands of Ute. Lead by Chief Ouray's brother, the natives attacked and killed Meeker and 10 others, taking five women as hostages. In 1879, word reached Red Cliff of the Meeker Massacre. Rumors persisted that the Ute were headed up the Eagle River Valley for Red Cliff. To protect the citizens, the men of the Red Cliff constructed a small fort of stone, which they named Fort Arnett. The citizens gathered near the fort for several days, and when no threat appeared, life went on as usual. The fort remained in case of further trouble.

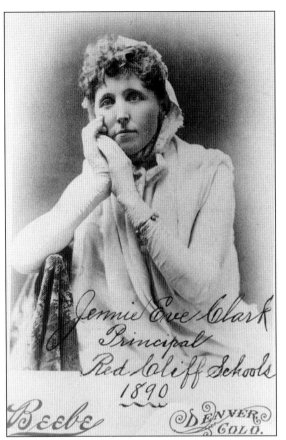

Jennie Eve Clark was the principal of Red Cliffs schools in 1890. Though there is a certain tendency to think of earlier pioneers along the Eagle River as crude and unlettered frontiersmen, Clark, dressed in her finery complete with white gloves, is quite the contrary. In 1900, a census showed that only 22 people out of a population of 3,008 were illiterate.

The Denver and Rio Grande Railroad reached Red Cliff in 1881. With the roads still difficult, travel by train was the mode. Until the start of the 20th century, Red Cliff remained the railhead for the mines, but within a few years, this changed when a line was built below Gilman at Belden along the Eagle River.

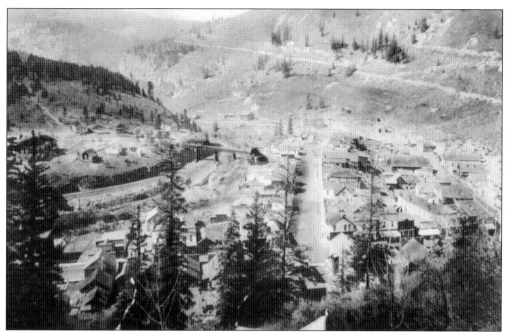

In this photograph of Red Cliff in 1914, looking west to the left is seen Fort Arnett and the toll road up Battle Mountain to Gilman. The main street visible passing Fort Arnett is Monument Street. To the right of Monument is Water Street and in the foreground is Eagle Street. At the corner of Monument and Eagle is the Quartzite Hotel.

Red Cliff continued to prosper through the years of mining boom and bust. The Denver and Rio Grande reached Red Cliff in November 1881. It became the county seat of newly formed Eagle County in 1883 until 1921, when it changed to Eagle. In the 1920s, Mickey Walsh's gas station was still thriving.

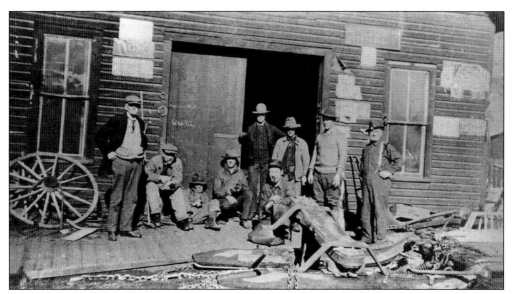

This blacksmith shop in Red Cliff was run by Mike Walsh. Pictured are Mickey Walsh (first row, kneeling), Oscar Mayer (second from right), and Mike Walsh (far right standing). In the foreground is a sled, used in the wintertime to haul goods. The town got its name from the red quartzite cliffs that surrounding it.

Due to the ample supply of wood, towns grew quickly and men made a good living in the lumber business. The Fleming Lumber Company in Red Cliff was a principal supplier of lumber for the mines and towns. Seen here in 1939, a man is working on framing timbers. In the background, equipment was being used to prepare the road for the construction of the Red Cliff Bridge.

An aerial view of Gilman shows the town perched on the side of the cliff above Belden. It is at an elevation of 9,000 feet. John Clinton, a prospector, judge, and speculator from Red Cliff, developed the town. He donated the land for the first schoolhouse and built the first boardinghouse. Clinton acquired the profitable Iron Mask Mine.

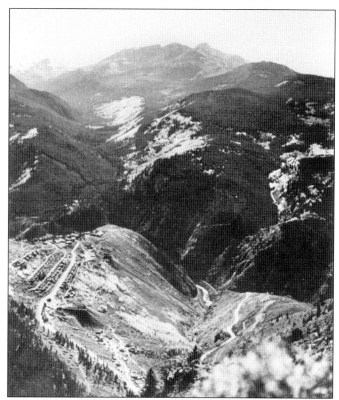

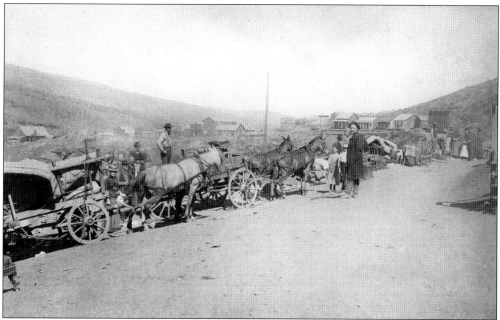

Evacuation was not easy when living in a town on a cliff. In this 1885 photograph, people have loaded their belongings and are lined up on the road below Gilman, waiting their turn to leave town ahead of the first fire in town. With the Eagle River so far below the town, it was difficult to contain a fire.

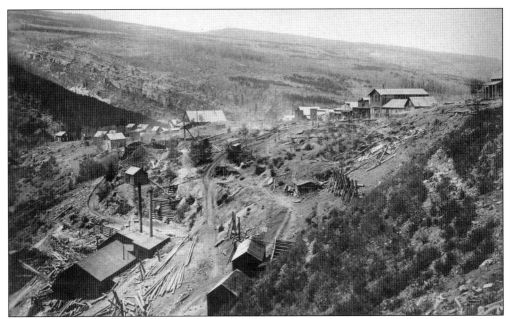

The Iron Mask Mine in Gilman is shown in this photograph sometime before 1886, since the mine was destroyed by fire in that year. In the upper right is a large pile of wood, all that remains from a house that was blasted to prevent a fire from spreading. Fire was a continual hazard in the early days of mining.

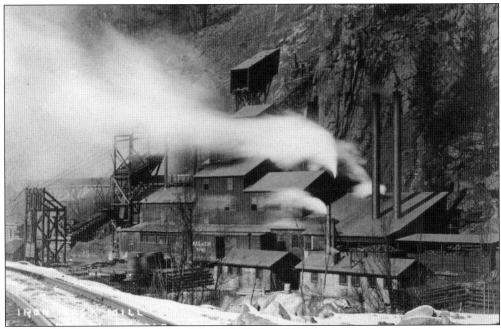

The Iron Mask Mill was in operation as of 1890. This old mill was torn down and a new one built in solid granite. In the Battle Mountain mining district, first silver was mined, next gold, but from 1905 to 1930, zinc was mined. Gold and silver once again were mined, but zinc remained important through 1959 and the mine continued going until the 1980s.

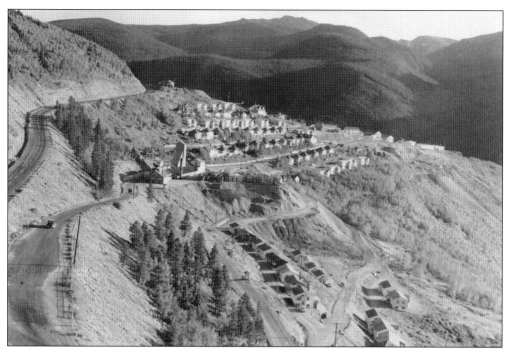

Starting in 1912, the New Jersey Zinc Company began to buy the principal mines and the town site of Gilman. From then on, it was called the Eagle Mine, and Gilman became a company town, employing many people. Gilman was a bustling town with a bowling alley, infirmary, and grocery store. For winter recreation, ice skating was available on the ice harvest lake at Pando.

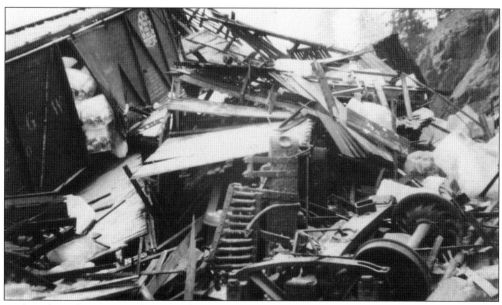

Each rail car leaving Pando carried a full load of ice blocks. The size of blocks can been seen scattered among the wreckage. The blocks weighed some 250 pounds. The blocks were pulled from the lake by an endless chain and onto a shaper to trim. Then the blocks continued down the endless chain to be loaded onto the rail cars.

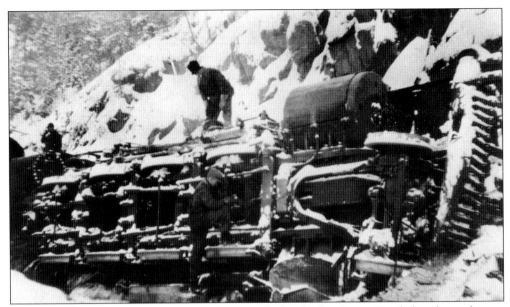

Hauling a heavy load from Pando in 1915, a train had its brakes freeze. Headed to the ice houses in Minturn, the train wrecked in the city limits of Red Cliff. For many years, over 40,000 tons of ice was harvested from Pando. In the winter, the river was dammed and a lake created. The lake was said to be 10 times bigger than a modern-day ice arena and was also used for recreation.

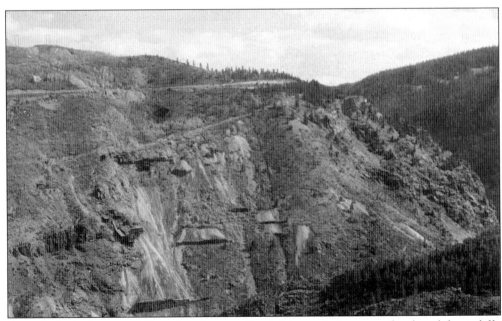

From the high plateau of Gilman looking east, Battle Mountain is a mass of rock and sheer cliffs. The road in the late 1800s can be seen just at the crest of the mountain. The numerous streaks near the midpoint of the mountain mark mine openings above Belden. Windy Point is in the top center of the photograph.

This early-1900s photograph of Belden shows the Denver and Rio Grande siding in the Eagle River Canyon below Gilman. Note the water tower in the photograph, plus wagons and equipment used in the mining operation. Most people lived above Belden in either Red Cliff or Gilman.

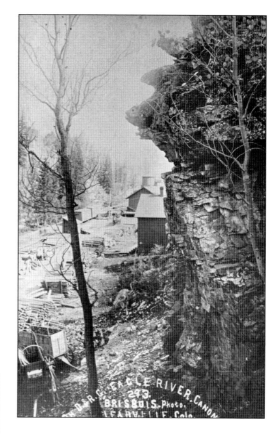

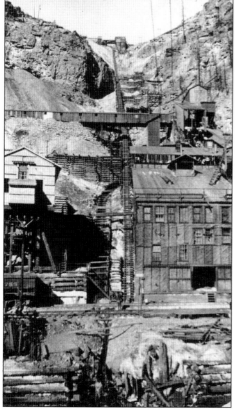

In the 1930s, the siding at Belden had grown as a result of the production of ore. In the earlier days, people rode the train and disembarked at Belden, riding a tram car up the tramway to Gilman. The Eagle River runs in front of this building, and cribbing can be seen that was built to hold the mountain in place.

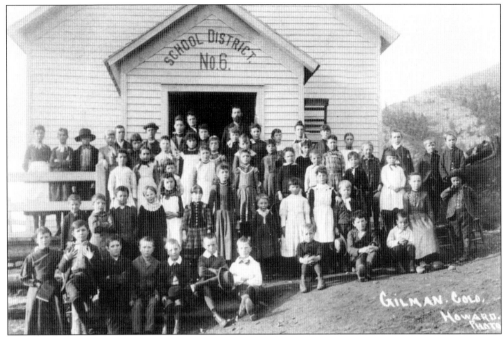

When Gilman began to prosper in 1890, school was in session for these children. By this time, Gilman had a saloon, which boasted the finest stock of liquors in the Eagle River Valley. H. M. Delano and W. F. Dunham were the owners. Besides the saloon, the building housed a billiard hall and club rooms.

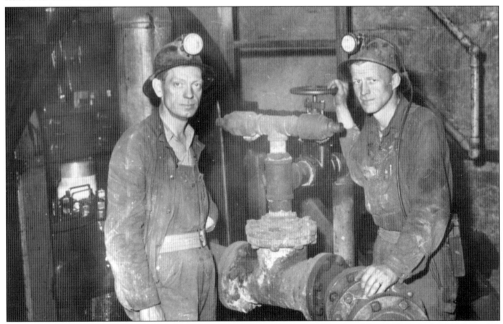

Dick Sayers (left) and John Skinner (right) are at the pumping station on the 20th level at the Gilman Mine. Water for the mine came directly from the Eagle River from the pump house, which was just across the ramp coming down the mill incline. About 50 tons of ore per hour went through the mill during each eight-hour shift.

Here is an example of a mine "stope" at the Gilman mine. A stope is an opening made so the ore can be mined. Timbers are used to support walls and also overhead for safe mining operation. For every miner who dug out the ore, there were other men that did all the rest of the work to actually get the ore to market.

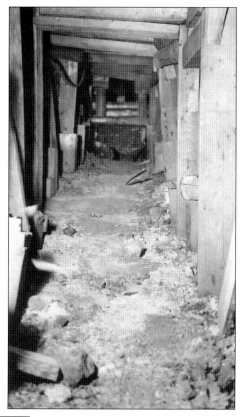

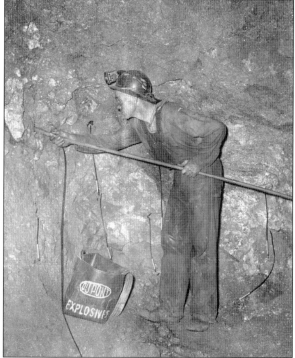

Here a miner tamps in dynamite prior to blasting a section at the Gilman Mine. Holes that have already been drilled are visible with electrical connections to the blasting camps and the dynamite. The bottom series of holes were detonated first to keep the miners from having to work so much loose debris.

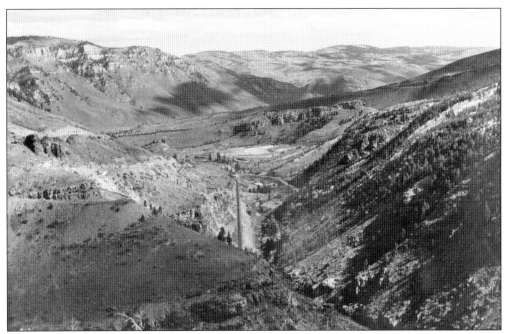

Waste from ore production from the Gilman Mine was piped down Battle Mountain approximately five miles to the tailings pond, which was just east of Minturn. The tailings pond can be seen in the back center. Some 8 million cubic feet of waste products have been estimated to have been dumped in this area, which was west of the Gilman Mine.

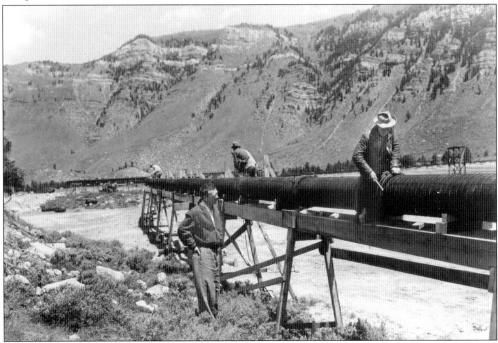

During the life of the mine, maintenance was done on the tailings pipes. However, when the mine was closed, tailings and wastewater were pumped back into the mine, the openings sealed, and the mine flooded. When the mine filled to river level, waste began to seep out of the mine.

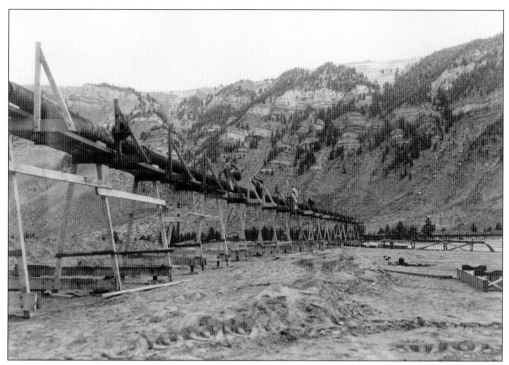

The tailings pond was supposed to keep mine wastes from flowing into the Eagle River. After the mine closed, the area was designated a Superfund site by the EPA. According to the EPA, toxic waste had been killing fish in the Eagle River and contaminated Minturn's drinking water. By 2000, the cleanup had been claimed successful.

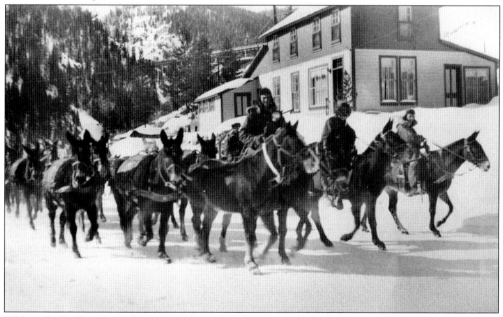

Although the Denver and Rio Grande Railroad steamed through Red Cliff and automobiles drove along Highway 24, four-legged animals continued to be a mode of transportation. This U.S. Army mule packer outfit passed through Red Cliff in 1944 on its way to Camp Hale.

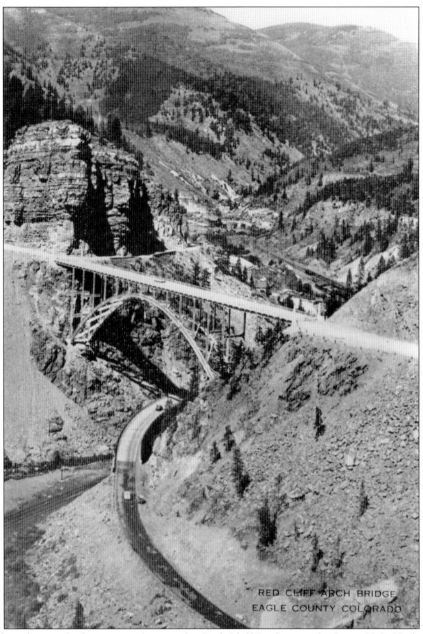

RED CLIFF ARCH BRIDGE
EAGLE COUNTY COLORADO

With the advent of a larger population, the Red Cliff Bridge was built on U.S. Highway 24, across the canyon where Turkey Creeks flows into Eagle River at the Red Cliff junction. The bridge was an engineering feat in its day, engineered by King Burghardt. Its span is constructed of reinforced concrete, while the arch is steel. It was completed on July 28, 1941, and dedicated and opened for travel on August 3, 1941. It is 209 feet above the river and 470 feet long with a 30-foot roadway. The bridge was entered into the National Register of Historic Places in 1985 for its contribution to the heritage of the state of Colorado. The bridge was the final link in 1,700 miles of U.S. Highway 24, the major east-west arterial road across the state. In 2004, after 60 years of use, the bridge went under massive rehabilitation. Today the bridge is still a spectacular sight with Lover's Leap looming overhead.

Three

MINTURN AND GORE CREEK

As with Gilman and Red Cliff, Minturn borrowed much of its life from Battle Mountain, both from the mining and from the Denver and Rio Grande Railroad. The early families settled at the confluence of Gore Creek and the Eagle River in the late 1800s. In 1885, the road from Leadville reached town, and in 1887, the railroad arrived. First named Kingston Station, and next Booco Station, the town was renamed Minturn in 1887 for Robert B. Minturn, a shipping millionaire responsible for raising the money to bring the rails west.

In 1890, there were 191 residents in Minturn. The most notable settlers were the Booco family, who gave some of their land to develop the town; John Kolnig, who made his home site north of the Eagle River; and Peter Nelson and his wife, Johanna, who made their home near Meadow Mountain and whose ranch was famous for its lettuce.

With the Eagle Mine in full production, Maliot Park was built along Cross Creek, which flows into the Eagle River. This was a park for employees of the Gilman Mine but open to the public. It was named after the mine's superintendent. Rodeos, picnics, and baseball games were a common occurrence at Maliot Park.

A quiet creek enters the Eagle River at Dowd Junction. It was named Gore Creek for St. George Gore, a wealthy Irishman, who led an extravagant hunting trip through Colorado in the mid-1800s. Settlers filled the bucolic alley along Gore Creek—Phillips, Baldauf, Shively, Ruder, Kiahitipes, Katos, and Haas, just to name a few. While some farmed, some were Greek sheep men. The road along Gore Creek to the Eagle River was so narrow in one place that two wagons could not pass. Many times in the winter, the road was closed.

In 1962, the Gore Creek Valley changed forever when Vail Mountain opened for business. Today the ski area is a world-class resort that hosts over two million skiers each year.

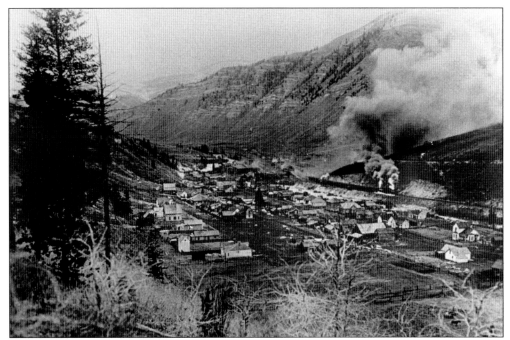

At the western end of Battle Mountain and Tennessee Pass, Minturn lies alongside the Eagle River. Early merchants erected buildings to supply the miners at the camps to the east and the ranchers moving to the lush meadows to the west. The Minturn Store was one of the first establishments near the end of the 19th century.

Opened in 1891, the Minturn Mercantile was the first merchandise store in Minturn. Built by Pierce and Richmond, it was constructed out of river rock. It housed a general store and dance hall for more than 75 years.

Mr. and Mrs. Jack Layton came to the Eagle River Valley about 1890. During his 50 years of residence here, Jack prospected every nook and cranny of the county. To get to the Homestake mining camps, he passed through Minturn. Happiest with a pick and shovel in hand, Jack searched for his lode of gold but never found it.

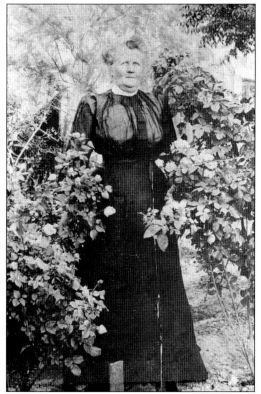

Standing outside between two rose bushes, Mrs. Jack Layton was a stately woman. She followed her husband on frequent prospecting trips to the mining camps. She was respected by her neighbors and stood by her husband while he scoured the mountains, hoping to find gold that would make them rich. The couple did not have any children.

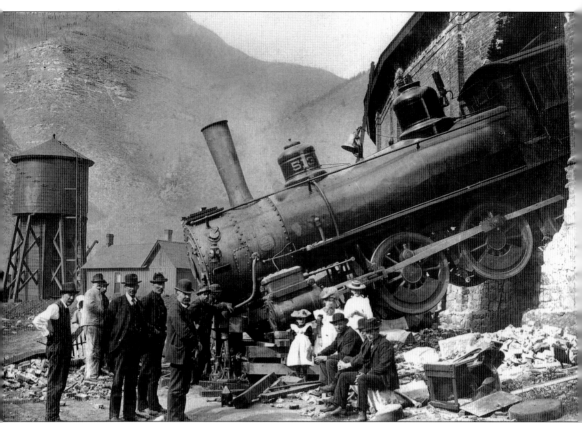

The Denver and Rio Grande served mainly as a transcontinental bridge line between Denver and Salt Lake City, Utah. With a motto of "Through the Rockies, not around them," the railroad was the major handler of coal and mineral traffic. With a grade of 3 percent to the top of Tennessee Pass at 10,200 feet, a roundhouse was built in Minturn to turn the engines around that were needed for the climb to Leadville. On this day in 1913, engine No. 513 was in the roundhouse with steam in its engine. The train started forward, but the brakes failed. The engine crashed through the roundhouse wall. Minturn was the division point between Glenwood Springs and Salida, an important service stop for the railroad. The year 1913 was when water lines were laid in Minturn and also the year that St. Patrick's Parish was built.

The railroad and its workers were a large part of Minturn's economy in the 1920s and 1930s. From Minturn to the top of Tennessee Pass, extra engines were added to pull the long string of freight cars up the steep grade. The extra engines required crews to operate and maintain them. Many railroad employees settled in Minturn.

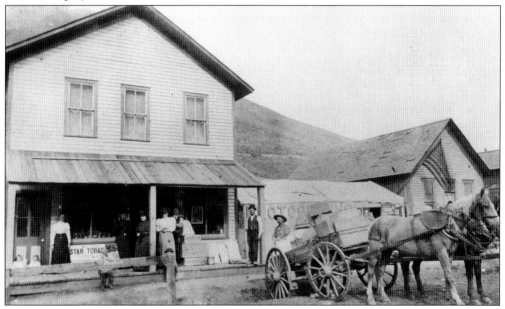

With the arrival of the railroad in late 1887, Minturn quickly developed into a booming crossroads for transportation and industry. By 1900, mining and railroad workers and their families raised the demand for business and services in town. This photograph was taken in 1900, four years before the town became incorporated.

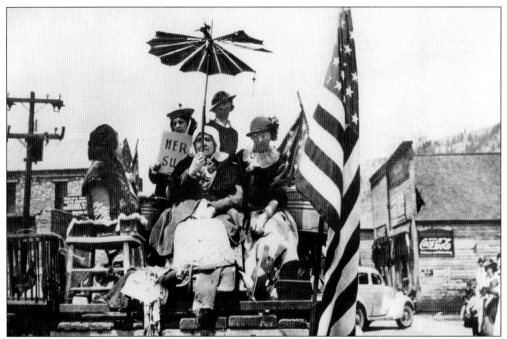

Not all the settlers in Minturn were miners or railroad workers. Many farmed and ranched as way of life. In the early years, the mining communities needed provisions. By 1935, the little town was thriving. A Fourth of July parade was a time for celebration. Here is a float with five people in costume.

Just east of the town of Minturn about two miles and along the banks of Cross Creek is Maliot Park. Named after Frank Maliot, who was the superintendent of the New Jersey Zinc Company mine in Gilman, the park was a place where people could come to relax, have a picnic, play baseball, and dance. Today it remains a park and is also a school campus.

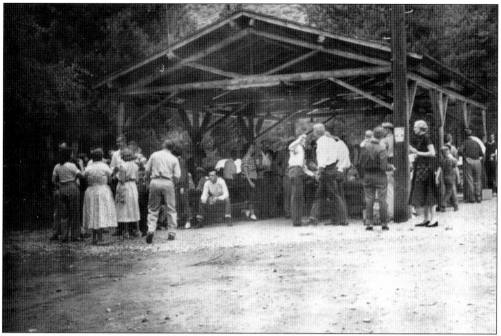

Under the shade of a log pavilion, employees and their families from the New Jersey Zinc Company get together. Here are Bill Jenkins (center), Alberta Judd (standing far right) and others. Although the park was owned by the New Jersey Zinc Company, it was open to the general public.

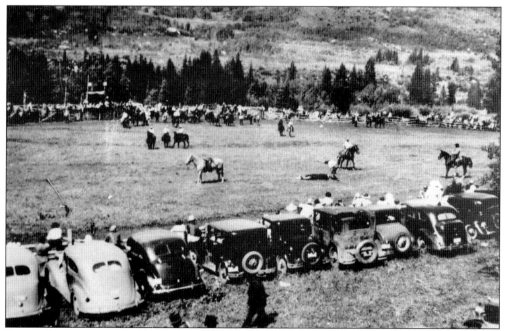

Raising horses and horse racing had been a casual pastime along the Eagle River Valley from the late 1800s. As cattle ranching became a profitable endeavor, cowboy skills came into play. Here at Maloit Park in the 1930s, a rodeo is in full swing. Spectators sat in their cars rather than bleachers.

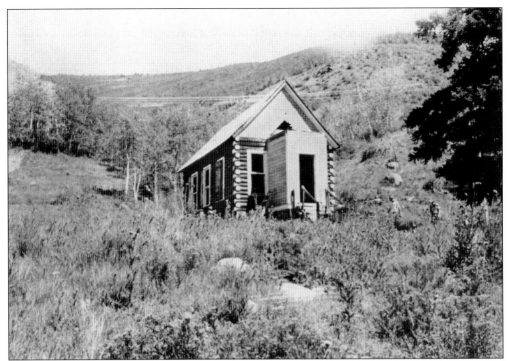

About two miles west of Minturn lies a deep cut in the rocky walls. To the northeast lies the Gore Creek Valley with Gore Creek running its length. Gore Creek was named for Lord Gore, an Irishman who hunted the area in the 1840–1850s. In the late 1880s, the first settlers came to the valley. School was held in the Gore Creek School on the north side of the creek.

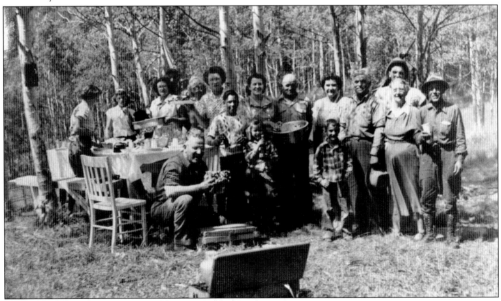

The Kiahtipeses, Greek sheep men, purchased a ranch along Gore Creek in the 1930s. In the summers, they grazed the sheep along Gore Creek. In the winter, they shipped them by railroad to Utah. Here the Kiahtipeses and friends prepare to serve a lamb that has been roasted over an open fire.

A family gathering for the Kiahtipeses was a happy event. Their family brand, the Circle-K, was imprinted on the chimney of the family home. That home is now the bus stop in East Vail, a reminder of times past. Sheep thrived on the early spring grass in the high county, and Vail Mountain was a favorite grazing ground.

Frank and Marge Haas bought 520 acres along Red Sandstone Creek where it flows into Gore Creek. Before the Haas family purchased the ranch, the Kellogs owned it and operated a sawmill. Frank worked as a logger while Marge raised rabbits. Later Frank raised pigs and fed them from the garbage collected at Camp Hale.

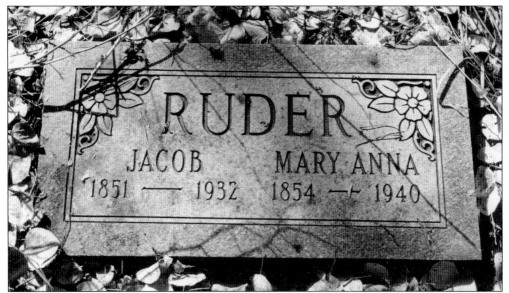

In the Intermountain Cemetery nestled in some pine trees uphill from Gore Creek is the resting spot for members of the Ruder family. The Ruders came to the Gore Valley in 1893 and settled in a log cabin along Gore Creek. This marker is for Jacob and Mary Anna Ruder. Members of the Ruder family reside in the area to this day.

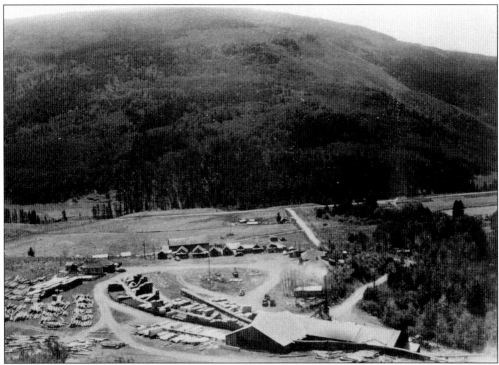

From the north side of Gore Creek looking down is the lumber mill located along Red Sandstone Creek. The mill was still in operation in the 1940s. Across the creek is the west end of Vail Mountain. Still covered with groves of aspen and pine, today the area is sliced with ski slopes and chair lifts.

Four

AVON AND
BEAVER CREEK

Some of the influx of miners to Leadville in 1879 filtered down the Eagle River Valley to where Beaver Creek joins it from the south and Berry Creek from the north. The English immigrants who arrived named it Avon after the Avon River Valley in England, home of William Shakespeare.

William Swift held title to the first piece of land in 1884 and was followed by George Townsend and John Metcalf in 1886. A few years later, others held titles: Hurd, Berry, Kendrick, Puder, Fleck, Rabadew, and William H. Nottingham. These early pioneers grew hay and raised cattle to feed hungry miners in Red Cliff. They also built irrigation ditches to supply all of Avon with irrigation water. Above Beaver Creek, a sawmill operated, providing wood to the growing community.

The first rail station in Avon opened in 1887.

After George Townsend filed claim on his property near where Beaver Creek flows into the Eagle, he acquired the Berry and Burnison homesteads. Eventually Townsend sold his ranch to John and Caroline Howard, and they sold to Gulling Offerson. Emmett Nottingham—the youngest son of William H. Nottingham—extended his ownership of land. When Emmett died, his son Willis began buying land in Beaver Creek and Bachelor Gulch, including the Offerson place. Eventually it became one big ranch. Clyde, Emmett, and Harry Nottingham owned most of the property of Avon on the north side of the Eagle River.

In the early 1920s, Beaver Creek and Bachelor Gulch became the center of lettuce growing in the United States. The lettuce was stored in lettuce sheds and then loaded onto refrigerated cars, which were kept cool by the ice harvested from Pando. From Avon, the lettuce was then shipped to the Midwest and the South. For several years, fortunes were made from lettuce but ended with the Depression. Meanwhile, ranching and farming continued in Avon, producing cattle, hay, potatoes, peas, oats, and sheep.

In 1972, Willis Nottingham sold his ranch to Vail Associates. It was then developed into the world-famous ski area Beaver Creek Resort.

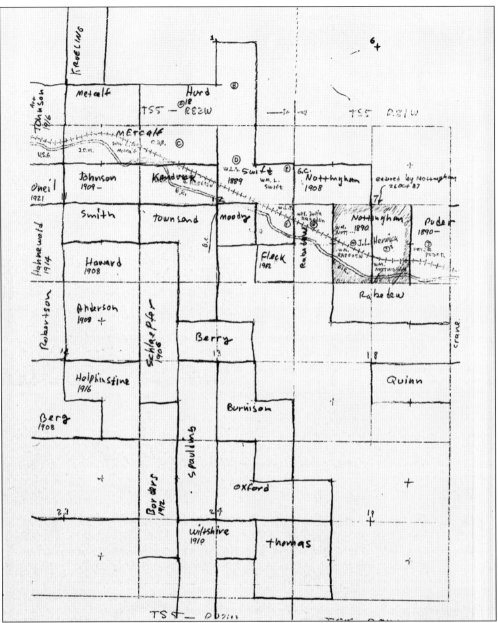

Early prospectors arrived in Leadville during the silver boom of 1879. Those who lost interest in mining migrated west. Early settlers who chose the broadening valley just west of Minturn staked homestead claims. First listed by William L. Swift as a railroad town in 1887, the town was named "Avin" but was changed to Avon. With an elevation of 7,430 feet, the Eagle River has dropped nearly 3,000 feet since beginning near Tennessee Pass. This drawing of the early claims shows who filed on which sections of land in Avon. Three of the earliest filings were those made by William Henry Nottingham, Peter Puder, and Ernest Hurd, people who would play a major part in the history of Avon. Those filings at the bottom of the map are located in the Beaver Creek drainage. In the center of the map is the number 12. Right about that spot is where the bridge crosses the Eagle River. (Courtesy Mauri Nottingham.)

Below the gypsum cliffs overlooking the Eagle River is a bucolic valley. Running its length is a sparkling creek that starts eight miles south, meandering through rocky crags and lush meadows. Beaver Creek flows into the Eagle River at Avon, just below angled sweeps of aspen and spruce trees. Early settlers liked this spot and stayed.

From the late 1800s through the dawn of the 20th century, 10 passenger trains a day passed through Avon. The depot sat on the north side of the Eagle River. In this photograph, a Denver and Rio Grande Railroad crew stands with a handcar in front of the depot.

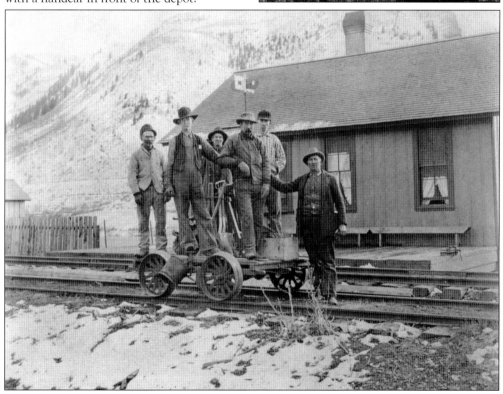

Early ranchers and farmers produced cattle, sheep, potatoes, peas, lettuce, and cream to feed the hungry miners in Red Cliff. With the Avon Depot on the north side of the river and the new ranches springing up in along Beaver Creek, a bridge was needed to cross the river. This photograph taken in 1928 shows the second Avon bridge with an overhead trestle.

From this viewpoint in front of the trestles, the early stores in Avon can now be clearly seen. On the left side of the road is the newly constructed Avon Hall and directly ahead is a newer Avon Store. The hall was built for social and political events. Highlights at the hall were the dances held there with the women contributing cakes and sandwiches.

The first settler recorded in Beaver Creek was George Townsend in the early 1800s. This photograph shows the road into Beaver Creek from the Townsend ranch. George Townsend married his brother's widow, Allie, after Sam Townsend, a lawman, was shot and killed in Leadville. Allie Townsend was considered the "first lady" of Beaver Creek. The Townsend place became a favorite stopover between Red Cliff and Carbonate.

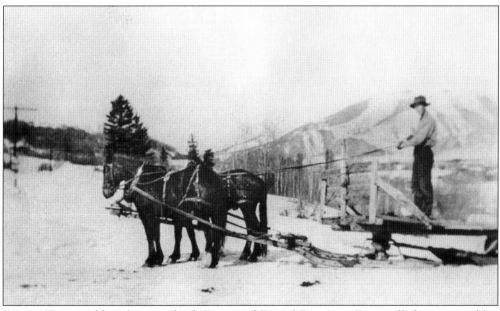

George Townsend bought out Abijah Berry and Daniel Burnison. Eventually he increased his holdings to 400 acres. In 1898, he sold the ranch to John and Caroline Howard for $4,000. Only four years later, the Howards left for Virginia, but their son Everett—standing on a sleigh in the photograph—remained to farm the land. Eventually Everett sold the property to Gulling and Olive Offerson.

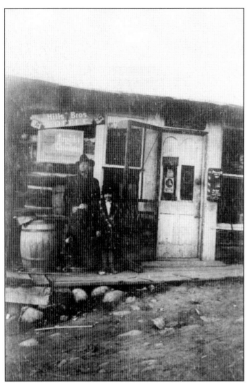

At the junction of Beaver Creek and the Eagle River, Stephen Andrew Bivans kept a general store. A sturdy six-footer of Welch origin, Stephen settled in Kansas and married Effa Litton in 1904. He built a wood structure, mounted it on a wagon, and brought it with him, and it became Avon's store. He was Avon's second postmaster.

Stock for the store arrived at the depot by train and was then transported by wagon to the store. Tired of long winters, the Bivans left in 1908, and Charles and Ester Adams took over the store. Tragedy struck when the Adamses' two-year-old son drowned in the Eagle River. Grief-stricken, the Adamses left the business. Today the Avon Store stands reconstructed at the Chambers Park in Eagle.

Early settlers in the area were surrounded by water. However, it didn't always flow where they needed it. To mitigate this, they built ditches for irrigation. Using a horse-drawn scoop called a Fresno, and sometimes dynamite, men and horses created miles of ditches. Then they grew crops such as potatoes and hay. This photograph is of the hay meadow in Beaver Creek, which is now a ski run.

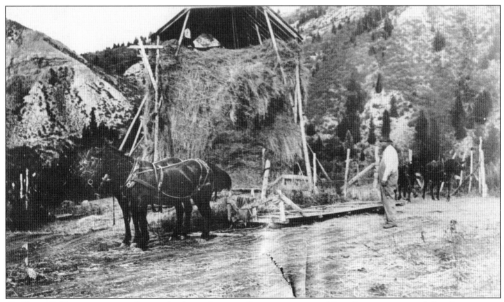

Gulling Offerson was proclaimed a first-class cattleman in several local newspapers. After lettuce rot and the Depression hit, settlers above Gulling slowly packed up and left the valley. There was only one road out of Beaver Creek through Gulling's property. When the settlers left, Gulling offered token amounts for the deeds to property and ended up owning most of the Beaver Creek Valley.

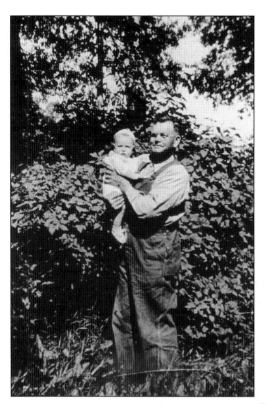

Gulling holds his grandson, Robert. In the 1920s, high-altitude lettuce was the big crop. Soon every field in the area sprouted manicured rows of pale green lettuce, irrigated by numerous ditches. After cleaning an irrigation ditch in 1941, Gulling crossed Highway 6 and was killed by a passing truck.

Gulling and Olive Offerson had one son, Austin, seen here in 1928. Behind them is the original house the Howards built. With each new owner, changes were made to the house. It sits at the entrance to Beaver Creek, proudly refinished as a grand reminder of earlier days. Today the building is Mirabelle Restaurant, welcoming travelers to the area who come to dine.

One of Avon's earliest settlers was William Henry Nottingham. In 1883, after landing in Red Cliff, he moved west and found the sagebrush-covered valley along the Eagle River. In 1886, he purchased the rights from J. R. Herwick to his 160 acres and found two partners to do the same: Puder and Hurd. The following years were difficult in the valley. Due to poor returns on the investment on the claim, Puder committed suicide. His parcel was divided between the two remaining partners. Managing the land gave way to difficulties between the two partners. Nottingham felt Hurd had poor management skills and told Hurd to stay off the land. Hurd, attracted to Angeline Nottingham, William's wife, retaliated by filing papers to end the partnership. The men argued. In one altercation, Nottingham pulled his gun, shot at Hurd, and missed. Hard feelings continued between the two partners, which would end in tragedy.

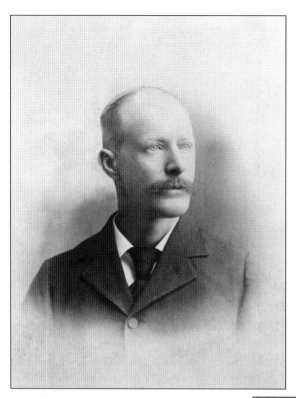

In 1896, both men traveled to Red Cliff to settle the matter in court. There business partners Ernest Vining Hurd and William Nottingham met and angry words were spoken. Both men pulled their guns. Ernest ran to the livery stable and hid in the hayloft. William followed. Ernest spotted William and fired his weapon. William died from his wounds. A court ruled the shooting self defense.

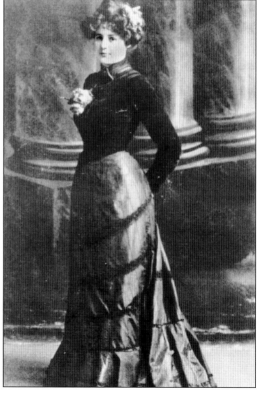

In another twist, Ernest Vining Hurd married Angeline Nottingham in 1899. In this photograph, she strikes a handsome pose. In 1901, Ernest traveled to the East Coast to visit his mother in Maine and his siblings in New York. While there, he was stricken with smallpox and died. With Ernest's family then quarantined, it was difficult for Angeline to find out what happened to her husband. (Courtesy Mauri Nottingham.)

In this studio portrait of William Smiley Cole and Mary Johnson Cole, both are formally dressed. Their daughter, Marie, married Henry Nottingham. Mauri Nottingham, their grandson, still resides in Avon. William Cole was the railroad station agent at the Avon depot. He also was station agent at Red Cliff, Browns Canyon, Salida, Grand Junction, Malta, and other places.

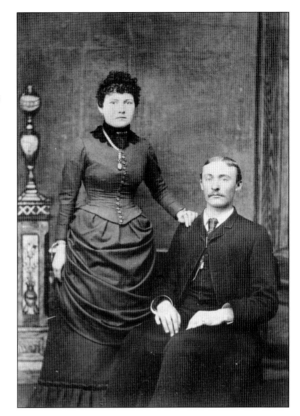

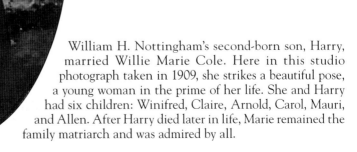

William H. Nottingham's second-born son, Harry, married Willie Marie Cole. Here in this studio photograph taken in 1909, she strikes a beautiful pose, a young woman in the prime of her life. She and Harry had six children: Winifred, Claire, Arnold, Carol, Mauri, and Allen. After Harry died later in life, Marie remained the family matriarch and was admired by all.

A young Harry Nottingham, finely dressed and with a serious tone, is nothing but handsome. Harry continued the ranching life in Avon and acquired the Kroeling place, laying claim to the western end of the Avon valley. His brother Emmett controlled the east end of Avon, and Harry acquired most of the land in the middle section.

William Emmett Nottingham (the third son of William H. Nottingham), as seen in this picture in 1923, was born in Bells Camp in 1893. Emmett continued the ranching life in Avon after his father died. A strikingly handsome man, he first married Francis and they had Willis. After Francis died, he married Myrtle and they had Imogene, William, and Charlotte.

Clyde Nottingham was the eldest son of William H. Nottingham. With younger siblings depending on him, times were difficult. Eventually Clyde was asked to leave the county because of numerous law infractions, including several physical altercations. Clyde and his wife, Myrtle, settled in Glenwood and opened the Pullman Café, across from the rail station as seen in this *c.* 1925 photograph. (Courtesy Mauri Nottingham.)

Emmett Nottingham's son, Willis, also thrived on the ranching life in Avon. After Gulling Offerson died, Willis and his father, Emmett, bought all of the Offerson land in 1950. Ten years later, Emmett sold his share to Willis. Willis and his wife, Willie, moved the family into the Offerson home.

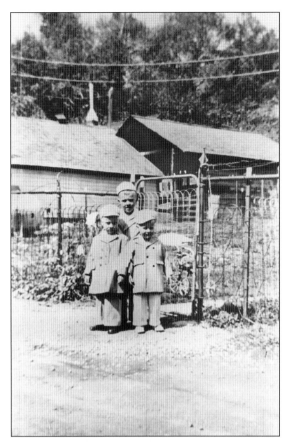

Willis and Willie Nottingham had three sons: Edward, Robert, and Michael. The boys attended the Avon School. Since their dad understood the difficulties of managing roads, fences, and ditches, the boys grew up learning how to take care of the land. Willis and his sons turned Avon and Beaver Creek into an efficient and profitable ranch. In 1972, Willis sold the ranch to Vail Associates.

Although this photograph looks like an abandoned hut of some kind, in fact it is a building that housed the water wheel of the Nottingham Power Plant. Built in 1928, it furnished power to the Nottingham ranch house and later to the Denver and Rio Grande Railroad Depot at Avon until 1941. The railroad paid $5 per month for power. The power plant has been listed in the Colorado State Register.

In 1908, the Nottingham barn sits along the Eagle River as it quietly runs past. The timber for the barn was taken from the pine forests in the immediate area. Visible in the background, behind the barn, is the first Avon Bridge built over the river, and above that can be seen the Avon School.

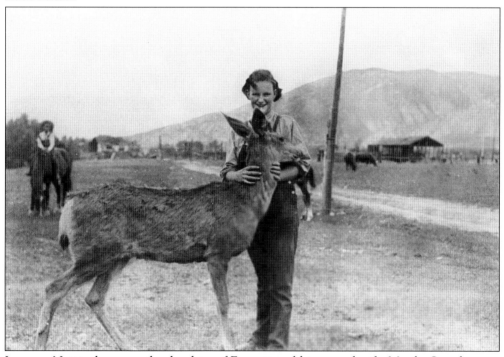

Imogene Nottingham was the daughter of Emmett and his second wife, Myrtle. Seen here on the ranch in Avon with a fawn the family raised, Imogene later married Frank Doll, one of the descendants of the original families in Gypsum. Thus two pioneer families joined with this marriage. Frank and Imogene remained in Avon and raised their family there.

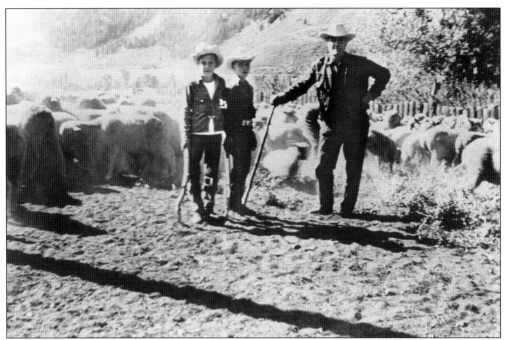

After the lettuce rot and Depression left the Eagle River Valley, the Nottingham family began sheep ranching. The land around Avon proved fruitful. In the summer, the sheep were moved to Bureau of Land Management (BLM) land high on the mountain slopes. In this photograph, Willis stands in a herd of sheep with two of his sons, Edward, left, and Bobbie, right.

Just south and west of Beaver Creek lies a hidden valley called Bachelor Gulch. Meadows and a stream blend in harmony to give the gully a sleepy quality of life. To this gulch came bachelor settlers: Berg, Mertz, Anderson, Smith, and Howard were the first. More came—Charlie Mays, Holbart, and a man named Archie.

This was a lively time in the era of Avon, Beaver Creek, and Bachelor Gulch. Some of the bachelors seemed odd. Ed Howard was deaf and kept his chickens in his house, some roosting on his bed frame. John Mertz only had one foot. Mertz and A. Holbart got in a fight, and Holbart shot Mertz through a door, destroying bones in his wrist.

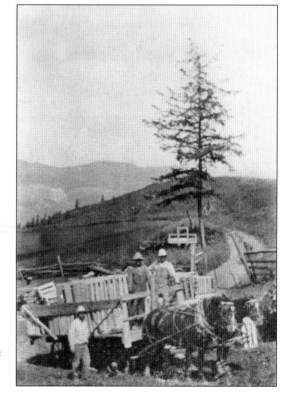

The lettuce craze hit Bachelor Gulch as well as Beaver Creek and Avon. In this 1923 picture, men and horses are working a wagon in the lettuce fields in Bachelor Gulch. In the foreground, the road down to Beaver Creek can be seen and, beyond that in the distance, the valley where the Eagle River flows through it. Today gentle ski runs grace the meadows where the lettuce grew.

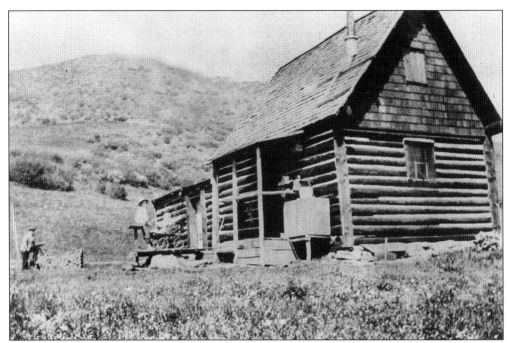

Another family who settled in Beaver Creek was the Eaton family, William and Nettie. They arrived in 1916. Although they only stayed two years, three of their eight children—Charley, Mel, and Denny—remained on in the county. Charley Eaton married Mable Thomas, who lived on a ranch above the Eatons'.

One of the Eaton children, Chester ("Chet") Eaton sits on a sturdy horse with the gypsum cliffs behind him. The Eatons first worked clearing land for Gulling Offerson at $15 an acre. Next they leased a ranch that encompassed what is now Arrowhead, just east of Avon. After that was sold, they leased the land that is Singletree. Finally they bought property in Squaw Creek.

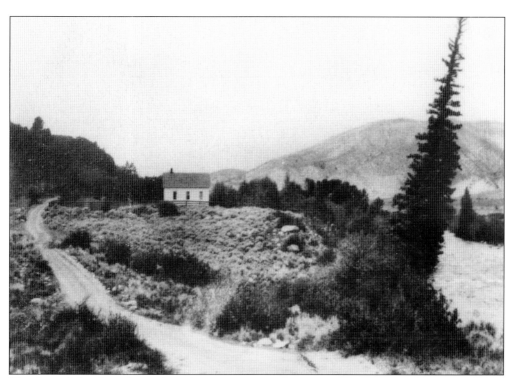

The Avon School was located on the bench overlooking the Eagle River. With children in families on the Avon valley floor and to the south in Beaver Creek, the school was an important place in the community. Those children across the river had to travel over the Avon Bridge to and from school.

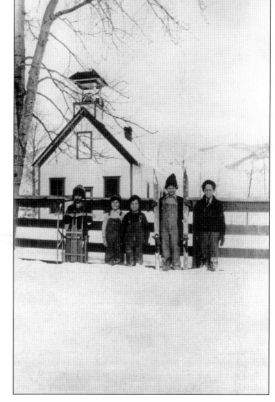

In this photograph taken in 1915, children line up in front of the Avon School. Each child has in hand his or her mode of winter transportation to the school. Behind the schoolhouse are barns and corrals for horses, yet another method of transportation for children when the weather was good.

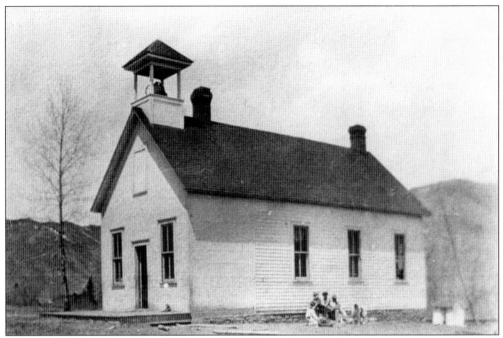

This photograph shows the Avon School in 1920 after the first addition was made, including the belfry. In front of the school was Johnson Lane (named for homesteader Joe Johnson). Johnson Lane led to Bachelor Gulch and meandered through Gulling Offerson's property to Highway 6. The school was torn down in 1948 to widen the highway.

The Avon students were a rowdy bunch. After one teacher quit, the call was placed to Denver for a replacement. Mildred Bailey arrived. Called the prettiest teacher ever, Mildred charmed her students. After Ev Howard from Bachelor Gulch met a hail of snowballs from Mildred and her students, he retaliated by courting Mildred.

In the late 1940s, a new Avon School was built. Constructed out of cement block, the new school was 200 yards east of Highway 6 and the entrance to Beaver Creek. It was only used for several years and then rented to Harry Nottingham. For many years, the building remained empty. In 1990, the building was sold and torn down.

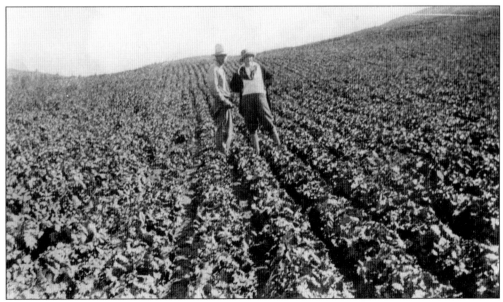

For about 30 years, lettuce was the new gold in the Eagle River Valley. High-altitude lettuce farming started in Buena Vista, and by 1923, every field in Avon, Beaver Creek, and Bachelor Gulch was covered with lettuce. For many years, the settlers in the area made a fortune with their lettuce crops. Guy Cates (left) and Teddy Tolbey (right) appraise the lettuce crop.

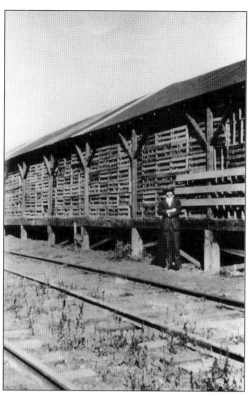

In Avon, three large sheds were constructed to hold the lettuce. Harvest time was busy. Most crates held 48 heads of lettuce, but some heads were so large that only 12 or so heads were able to be packed in a crate. Once the crates were filled, some ice was tossed on the lettuce and it was then stored in the lettuce sheds, waiting to be shipped out.

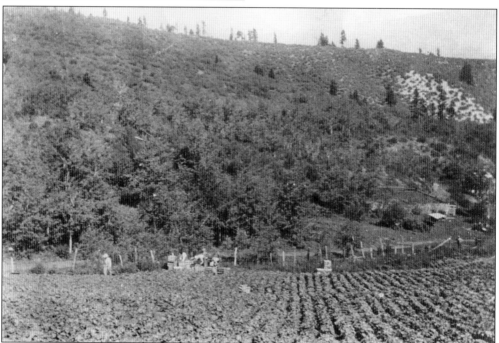

Due to poor farming methods, the lettuce rot, and the Depression, the lettuce boom fizzled, just as the gold rush did. For many years, the fields remained empty. The small farmers began to sell their land. This photograph shows lettuce pickers in Avon working a fertile field in 1923.

Five

EDWARDS AND WOLCOTT

Perhaps no place is as breathtaking as where Lake Creek joins the Eagle River at Edwards. Lush meadows lay beneath majestic peaks in the Sawatch Range, and here the Eagle River slows its pace, looking more like a broad lake rather than a river. On a bluff overlooking the river, Joseph Brett staked his claim. A French native and horticulturist, Joseph migrated to the United States in 1877 and to Leadville during the silver strike. He discovered the bucolic spot on a bench overlooking the Eagle River and built his ranch. He was friendly with the Ute Indians, and his wife, Marie, was well known for her cooking.

After the Denver and Rio Grande Railroad built a station in Edwards, people from Leadville rode the train to "the Frenchman's," a resort for hunters, fishermen, and recreation. Brett married Marie Guenon and they had four children. Today the home still stands on a little knoll surrounded by evergreens. Overlooking the still waters of the Eagle River is the Brett family cemetery.

In 1882, Harrison Berry located a ranch where the railroad station was on the north side of the river. When the line reached the place in 1887, it was called Berry's Ranch but was later changed to Edwards after Melvin Edwards of Red Cliff, who became secretary of state for Colorado.

Although gold was mined in Lake Creek and at one time a stage ran from Edwards to Fulford, mining did not prosper. Mostly ranching drove the economy with some lumbering done along Lake Creek.

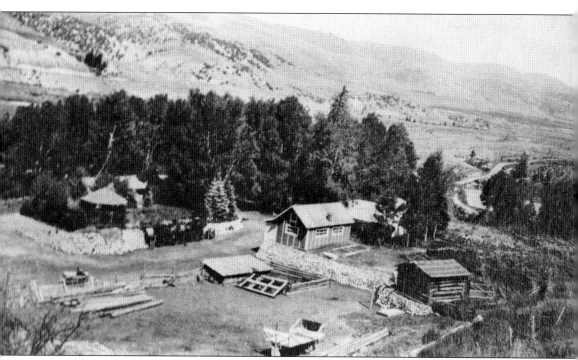

Joseph Brett was the first settler along the Eagle River. He is listed as a resident in the area as early as 1878. Here is a photograph of the ranch he built overlooking the slow stretch of the river. In the early days at the ranch, he welcomed the Ute Indians to his campfire. Although Brett got along with the Ute Indians, he took precautions after the Meeker Massacre and built a stone wall around his ranch house. When the railroad arrived in Edwards, the Brett Ranch became a favorite resort for the businessmen of Leadville. After boarding the train in the morning, they would arrive at Brett's and hunt or fish and partake of the wonderful cooking done by Marie Brett. By boarding the train in the afternoon, travelers could be home by evening. It could be said that Joseph Brett began the resort business in the Eagle River Valley.

A handsome man, Joseph married Marie Guenon in 1882. The couple had four children, two sons and two daughters. It was said that Marie was a fabulous cook, and many people came to visit the Brett Ranch just to savor one of Marie's meals. The children attended the Edwards school. Although Edwards did not grow into a prominent community such as Avon or Minturn, it did not suffer some of the setbacks the other mining and farming communities felt. With its spectacular natural setting and a backdrop to majestic mountain peaks, the community slumbered along with ranching as its mainstay and a little lumbering done on Lake Creek. Today the fishing is equally as good as it was over 100 years ago.

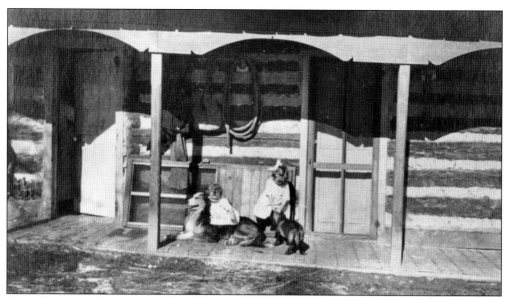

Two of Joseph and Marie's children play outside on the front porch of the Brett family ranch with a couple of their dogs. Built before 1900, the house was hewn from logs and chinked. The house overlooked the Eagle River and out back had a vegetable garden, corrals, and a barn.

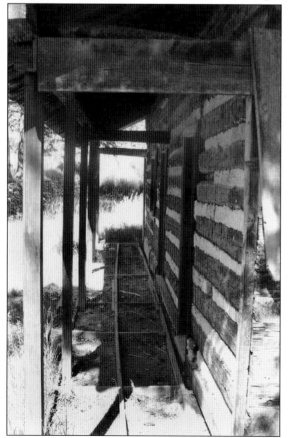

The Brett Ranch is made up of the oldest surviving buildings along the Eagle River corridor. In the days that Joseph Brett built his ranch, there was no sawmill to provide lumber for the buildings. Today the buildings still stand, but modern development is encroaching on the site. In this photograph, one can see the walkway with the original chinking in place.

In the winter of 1885, Joseph and several other men ventured out to retrieve an elk they had killed. It turned cold and Joseph got his feet wet. When he returned to the ranch, his feet were frozen. He was taken by sled to Red Cliff. Both feet were amputated at mid-step. After several months recovering, he continued his active lifestyle. Joseph lived in the house he built for over 50 years.

Early life along the Eagle River was not always happy. One of Joseph and Marie's daughters died in infancy. A son, Joseph James, died when he was a young man after a lingering illness. The Brett family cemetery sits on a little knoll, overlooking the ranch and the slowly moving Eagle River. Tall pines shade the graves, and it is a perfect spot for the final resting place for the Frenchman and his family.

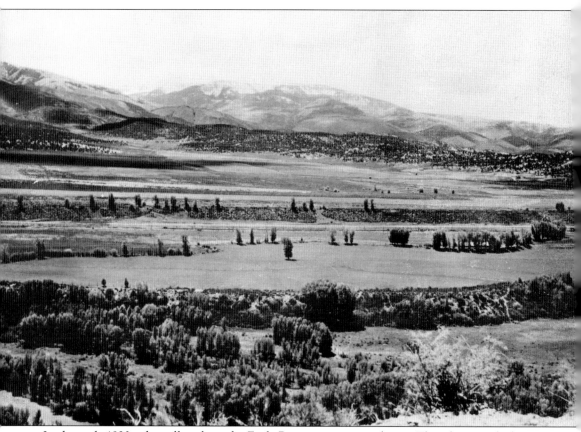

In the early 1920s, the valley along the Eagle River was a tranquil spot. This photograph shows the valley floor with the river running in the center of it. It is taken from the north side of the river, probably about where the railroad tracks went through the area. At the very right-hand edge of the picture and across the river would be Brett's ranch. There are no gushing rapids or treacherous holes, just a lazy river taking its time to enjoy the scenery. The mountains in the foreground are called the Sawatch Range with New York Mountain the highest peak at 12,546 feet. It was on this side of New York Mountain that, on New Year's Day in 1892, Arthur Fulford died in an avalanche. At one time, a stage ran between Edward and Fulford and traveled up the Lake Creek Valley, although the main access point to Fulford was from Brush Creek.

In 1882, Harrison Berry began the ranch where the railroad station was located. First called Berry's Ranch by the Denver and Rio Grande Railroad, it was changed to Edwards after Melvin Edwards of Red Cliff, later the secretary of state for Colorado. Most of the economy of the area came from ranching, although there was a lumber company up Lake Creek.

The head of Lake Creek runs into a wall of crags and rock. It looked like a good spot for mineral exploration. A group of doctors from Toledo, Ohio, formed the East Lake Milling and Mining Company. The mine was worked for several years, but little ore was shipped. W. H. Wellington (at the extreme left) organized the group and brought them to the area around 1910.

As settlers came into the area, the need for a school was evident. The first school was built along Lake Creek and called the Lake Creek School. In this photograph, the log schoolhouse can be seen in the background. The woman on the right, dressed in long skirts and petticoats, is riding sidesaddle.

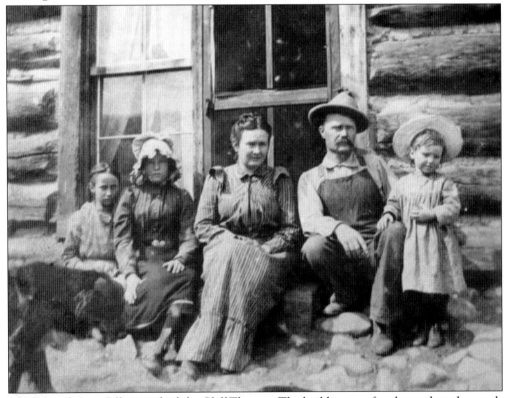

The Edwards Post Office was built by Cliff Thomas. The building was first located on the north side of the Eagle River near the railroad tracks. When Highway 6 was built, the store was moved to the south side of the river. Carl Eaton, who had a sawmill, furnished the logs for the building. The building still stands at this location today.

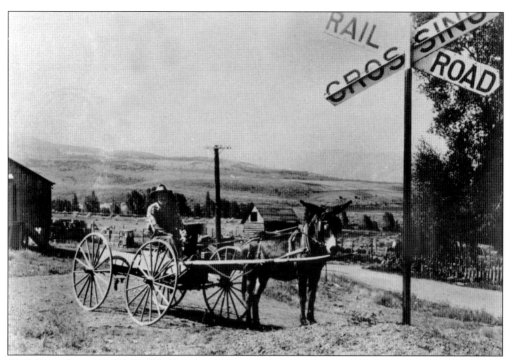

To deliver the mail, W. H. "Dad" Wellington and his donkey Pete met the train at the station in Edwards. Then driving the mail wagon, Dad Wellington drove the wagon to the Edwards Post Office across the river. The Edwards lettuce sheds can be seen on the far left in this photograph. Wellington delivered mail twice daily for over 42 years. Wellington enjoyed taking Pete out with members of his family. Here is he in the mail buggy with his grandson, John Wellington. They are near the train depot on the north side of the river. Below them would be the river, and across in the far distance is the entrance to the Lake Creek Valley.

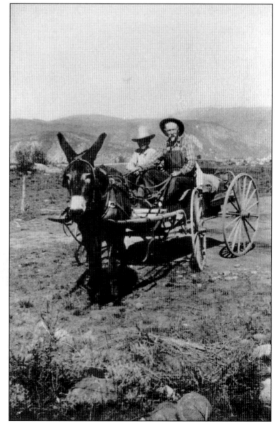

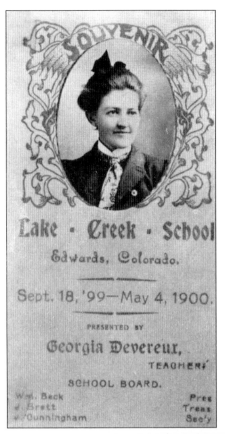

For the Lake Creek School in Edwards, a commemorative photograph was produced for the school year 1899–1900. Georgia Devereux was the teacher. The school board consisted of William Beck, president; Joseph Brett, treasurer; and a J. Cunningham, secretary. The photograph was mounted on cardboard.

Ten years later, Georgia Devereux was still the teacher at the Lake Creek School in Edwards. She is standing center right in this photograph. She is surrounded by 24 students. The school was located on a knoll overlooking the Eagle River. About that year, the *Colorado Business Directory* listed Edwards as having a population of 27.

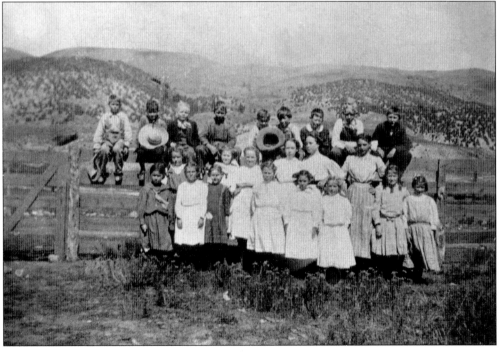

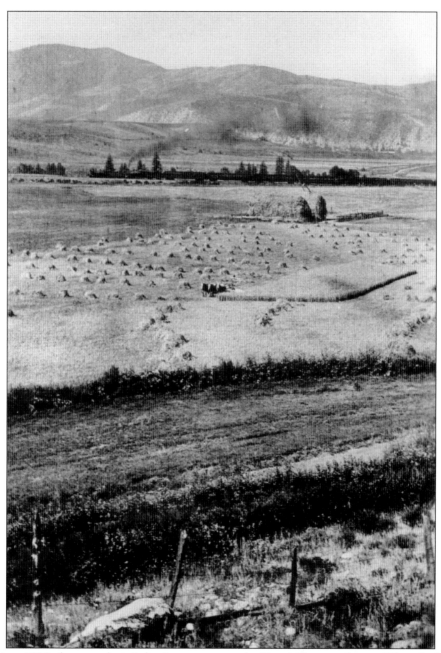

In this *c.* 1920 photograph, it is haying season on the Koprinikar ranch near Edwards. In the center, a team of three horses is working the field while hay is stacked, waiting to be taken to the ricks. In the background, a train is passing by. This scene is what the earlier travelers to Brett Ranch might have seen when they took the train to his place for a day of relaxation. Lake Creek still remains a tranquil spot, dotted with small ranches. Sheep graze the sage-covered hills in the spring and fall, guarded by dogs and shepherds. While downtown Edwards was not much except a train depot and post office, today it is a bustling community with shops and restaurants. Today the Koprinikar ranch is now the sight of Singletree Golf Course, and Interstate 70 runs right about through the hay field.

On a clear sunny day, lettuce workers pause for a photograph to be taken. The year is 1932, and the truck is bound for the lettuce sheds in what was called Allenton, near Edwards. Charles A. Penny raised lettuce. He had a ranch in the Edwards area and married Tese Hohstadt, whose family ranched near the mouth of Squaw Creek.

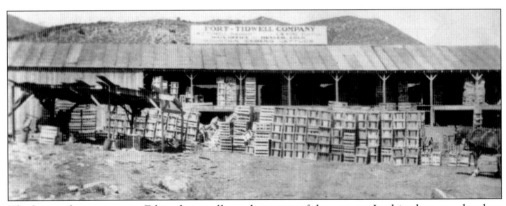

The lettuce boom came to Edwards as well as other parts of the county. In this photograph taken of the lettuce shed at Allenton in 1939, stacks of crates are lined up outside the shed. The sign on top of the building says "Fort Tidwell Company."

Starting out with the name of Russell, Wolcott became a prominent town as the shipping point for cattle. In 1886, a wagon road was completed to Steamboat Springs, and the following year, the railroad arrived. In the peak years, 2,000 carloads of cattle were shipped from Wolcott.

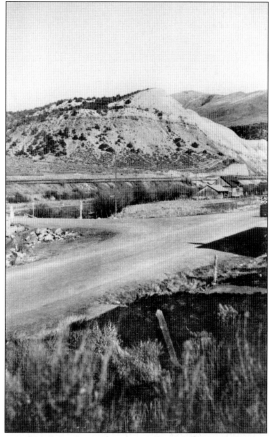

From 1886 to 1906, a Concord stage, drawn by six horses, made the trip from Wolcott to Steamboat Springs. More than 30 wagons, loaded with supplies, also left Wolcott and started up the long hill to Steamboat Springs each day. Wolcott's prosperity came to an end after the Moffat Railroad was built, reaching Steamboat Springs in 1908.

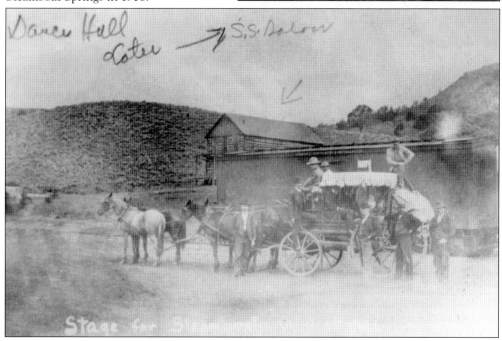

As the burg of Wolcott grew, a hotel, general merchandising store, blacksmith shop, and saloon were maintained. In 1911, J. S. Ridgeway was the postmaster and the town boasted a population of 75. Form left to right, Mrs. Playford, Johanna Holland, and Mrs. Hanscomb stand in front of a log building in Wolcott in this *c.* 1897 photograph.

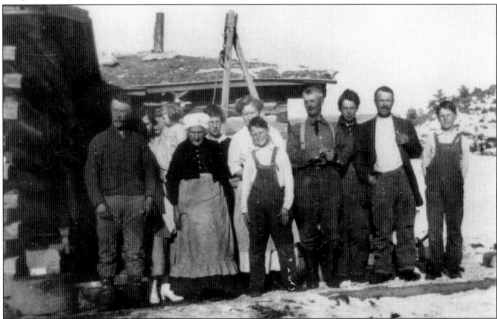

The Booco family is steeped in the history of our country's fight for liberty and freedom. William Booco came west in 1879 and settled in Wolcott. His son, George, donated land for the town of Minturn to be developed. William's grandfather accompanied General Lafayette to America and fought in the Revolution. George's paternal grandmother was a sister of General Sherman.

Six

EAGLE

From its inception, Eagle had many different names. Prior to 1887, it was called Brush. In 1887, it was named Castle. In 1990, it was called both Eagle River Crossing and Rio Aquilla. In 1896, it acquired the name McDonald. Finally in 1905, it settled on the name Eagle. The town of Eagle sits along the Eagle River at the mouth of Brush Creek Valley, ending at the Sawatch Mountain range. To the north is a view of a rocky crag known as Castle Peak. The mining community of Fulford was the last mining camp developed during the gold rush days, just north of Brush Creek on a rocky slope, separating Brush Creek from the Lake Creek Valley.

Henry Hernage settled the first ranch at the mouth of Brush Creek in 1882. In 1890, the population of Eagle was listed as 25. In the beginning, all supplies had to be transported from Red Cliff on a rough trail. Water was carried from the river. In 1895, the town site was sold to A. A. McDonald for taxes. In 1896, the town failed and the name changed to Eagle. With the mining community of Fulford springing up below the mines on New York Mountain, Eagle began a brisk business of serving those in Fulford. The Hadley brothers had a stage line, and the first newspaper, the *Eagle Country Examiner*, began printing in 1899. Fulford would have two mining booms: gold and then silver. Neither proved lucrative, and the camp eventually died. These days it is a summer cabin community.

Cattle were introduced to the Eagle Valley by Webb Frost, J. W. Love, and G. S. Wilkinson and remained a strong livelihood long after mining died. In the following years, agriculture also thrived. In 1921, the county seat was changed from Red Cliff to Eagle. Today Eagle is a thriving community with a population nearing 6,000.

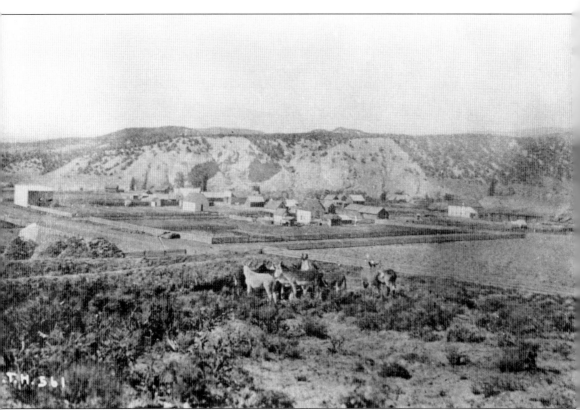

In this very early picture of Eagle around 1895, the town was called McDonald. The town was the center of a fine agricultural district, surrounded by boundless pasturelands for stock owned by Eagle ranchers. It was situated near the confluence of Brush Creek and the Eagle River. Brush Creek had a limitless water supply, excellent ditches, rich land, good fences, residences, barns, and granaries. With the mining camp of Fulford 18 miles south, Eagle was a natural outfitting point. The view in this photograph is from the northwest looking southeast with Brush Creek to the right. Overlooking the town are eight donkeys. To the far left is a Fourth of July canvas-roofed celebration hall built by A. A. McDonald. Currently the site holds the Masonic Hall. By 1899, the town had three stores, two hotels, a livery barn, one saloon, and a fine schoolhouse.

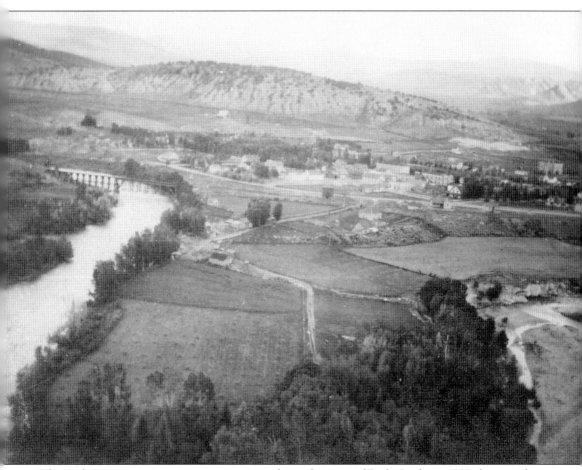

The Eagle River continues its journey westward past the town of Eagle. In this c. 1932 photograph, the railroad bridge can be seen. In 1879, Congress passed the Desert Land Act, which allowed a person to claim 640 acres at 25¢ an acre. If within three years a claimholder irrigated the land, they could then purchase it for an additional $1 an acre. Thus large ranches could be obtained. The broad valley in the background of the picture is Brush Creek Valley. A lush, broad valley, it meanders southward until it backs up to the Sawatch Mountains. The mining camp of Fulford was founded when minerals were discovered there. Many of the mines are at the top of the New York Mountain located in difficult scree fields. Today the town of Fulford is a quiet place with rustic cabins still standing. There is a story of a lost mine there, and from time to time, people are seen searching for Buck Rogers's lost mine.

During the period 1820–1860, Native American–European relations were friendly for the most part. The Ute were receptive to the barter system and traded with the first Europeans in the area. When the first white men arrived in the Rocky Mountains, the Ute Indians were happy to trade goods, since these Europeans provided the Ute with items they could not provide for themselves. With the influx of Euro-Americans to the east and the Mormons to west, the Ute began to feel pressured and after several skirmishes, they were removed to a reservation. When the new Indian agent at the White River Agency tried to turn the nomadic tribe into farmers, the Native Americans revolted. Finally tensions ended with the Meeker Massacre and the kidnapping of five females. Soldiers hunted the renegade Ute braves. Due to Chief Ouray's help in negotiations, the victims were safely returned to their families, but the fate of the Ute Indians was sealed forever. In this picture above the MacDonnell ranch in Brush Creek is a wickiup used by the Ute Indians.

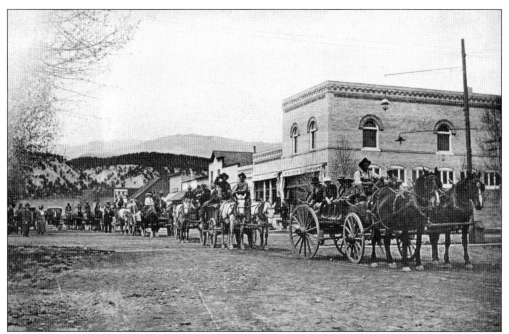

The town of Eagle survived a couple of mining booms and busts because of the mining operations above Fulford. The end of the first boom was in 1903. In 1913, the silver rush began but ended in 1918. This *c.* 1918 picture shows wagons traveling down Broadway. Streets were wide to give room for horse-and-wagons teams to turn around.

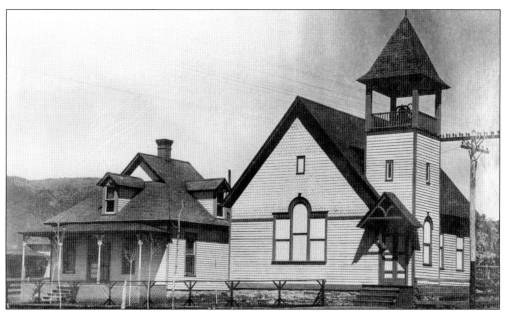

The Eagle Methodist Church was built in 1900, complete with bell tower. The smaller building to the left in the photograph is the parsonage, built in 1902. The first official resident was either Reverend Gordon or Reverend Bonnell. In order to pay the preacher's salary, members of the congregation went door-to-door to solicit donations. The house was moved in 1958 when a new parsonage was built.

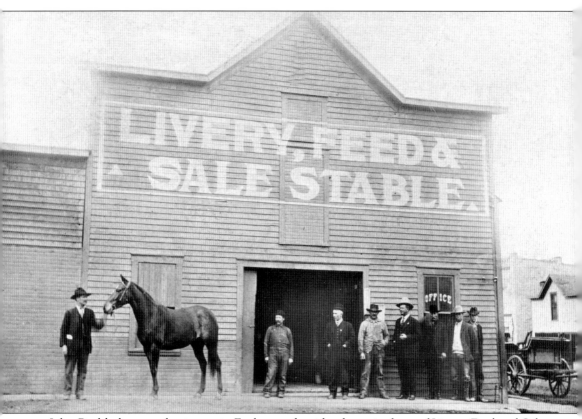

John Buchholz, an early pioneer in Eagle, stands with a horse in front of Livery, Feed and Sale Stable at Second Street and Broadway in Eagle in 1908. John holds one of his prize horses for the photographer. This livery was the place where Sam Doll, Jake Borah, and John Buchholz gathered with others to talk about horses. Born in 1870 in Washington, D.C., John and his parents, Nicholas and Molly, and family first came to Leadville when he was seven years old. The family then moved to Eagle in 1892 when he was 12. John married his wife, Mary Louise Warren, in 1898. She died in 1910, leaving John with two young children, Beulah and Nicholas E., to raise. The family settled on land that was then called Buchholz Mesa. John helped build a horse racetrack across the river, and exciting races were held there. Devoted to the livestock business, John trained saddle horses that were in great demand in the area.

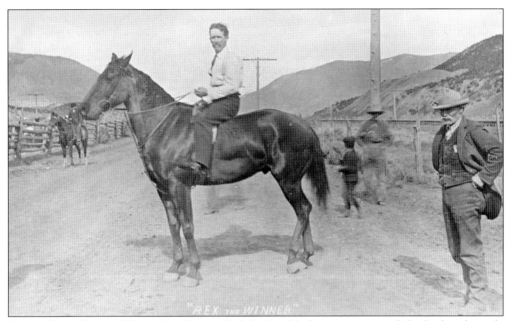

Involved with horses all his life, in his youth, John Buchholz was an accomplished rider who rode in numerous horse races. In this photograph, John sits on Rex after a 600-yard dash against Grizzly Bell. The race was held at Wood's Lane in Eagle in 1908, and yes, Rex was the winner.

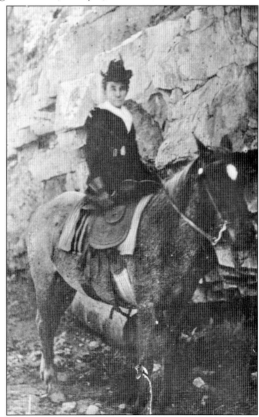

In this picture in the early 1900s is Molly O. Adams Buchholz. She was the mother of John and wife of Nicholas Buchholz. With her family, she traveled to the Eagle River Valley from Washington, D.C., in 1879. She is riding sidesaddle, which was the custom for women at the time.

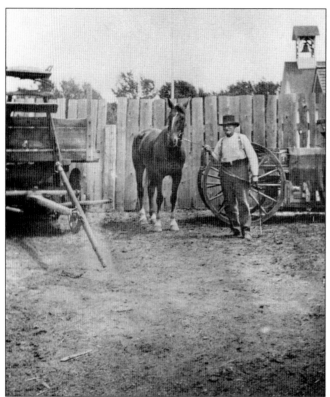

Standing in this *c.* 1908 photograph is Bill Burt. Behind him is the bell tower of the Eagle School, which is now St. Mary's Catholic Church. Holding the reins of a fine-looking horse, Bill is standing on property belonging to the Buchholz Livery Stable. Horse racing and rodeo were common amusements at this time.

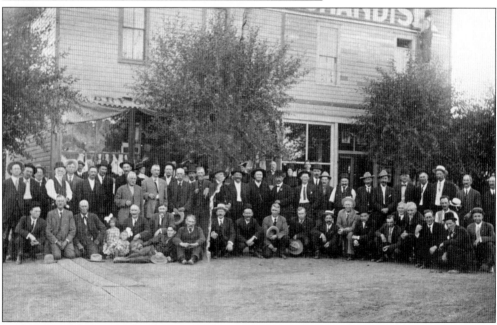

Nicholas Buchholz owned and operated the Livery, Feed and Sale Stable at the corner of Second Street and Broadway with his son John. As a testament to his many years as an Eagle resident, the funeral gathering for Nicholas in August 1911 was well attended. He was the county assessor at the time of his death.

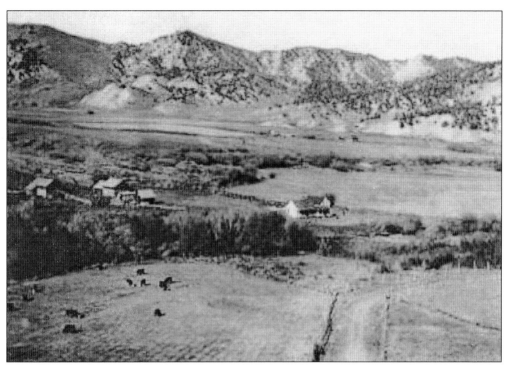

This photograph is taken from an overlook of the old Dice place along Brush Creek, home of one of Eagle's early families. Brothers Harve and Tom Dice were instrumental in constructing several of Eagle's first buildings on Broadway. They built the Dice Building, which housed a saloon and poolroom and later the post office.

Harve and Tom's brother, Joe, had a son, Fred. Fred's son, also named Joe, is pictured here at age 10 on his horse, Sally. They are at the Half-Way barn along Brush Creek around 1939. The Half-Way barn was a stage stop for the Eagle-to-Fulford stage line. Traffic was busy between Fulford and Eagle. The barn was roomy enough so that freight wagons could be stored and horses switched if necessary.

A broad valley that narrows and twists and turns as it finishes its course against the Sawatch Mountain range, Brush Creek is filled with lush meadows and plateaus. Ranchers found these areas. Here on the Schlutter place in late spring, a calf is being branded, while another calf waits its turn.

Not everything in Fulford was rock and trees. There were pretty meadows along the way that invited settlers to stake a claim and stay. The town of Fulford was first called Nolan after an early settler who died after he crossed a log and his rifle shot off his tongue. The name was changed to Fulford. This picture is from the Frank Newcomer ranch around 1900.

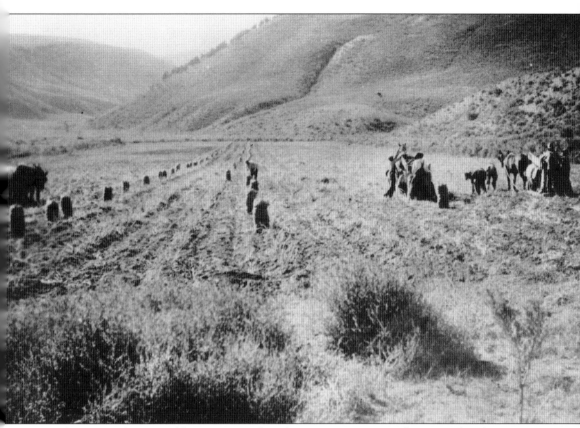

As the mining boom and bust continued in the mining camps, settlers turned to farming in Eagle and along Brush Creek, just as they did in Avon, Beaver Creek, Edwards, and elsewhere. The major crops in the area included potatoes, lettuce, peas, hay, and grain in the early 1900s. In this picture, workers dig and sack the potatoes. Next field workers sack the potatoes from the boxes and stack the filled bags on the ground. The work was backbreaking. The farm kids dug and sacked potatoes and would probably rather have been in school. At least eight people were required to dig, pick, sort, and ship the spuds. The sacks weighed about 100 pounds each. Along Gypsum Creek, there are several golf courses where the potatoes used to grow. However, old wooden potato sorters still sit along the creek bank.

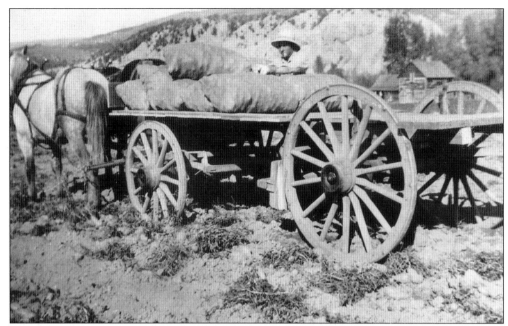

The right combination of cool temperatures and sandy soil made for the perfect growing conditions for potatoes. The wagons took the sacked potatoes to the "spud" cellars, where they were stored until moved to the railroad for shipment. Eagle, Brush Creek, and Gypsum were known for their high-quality russet potatoes. This photograph was taken on the Shryack place.

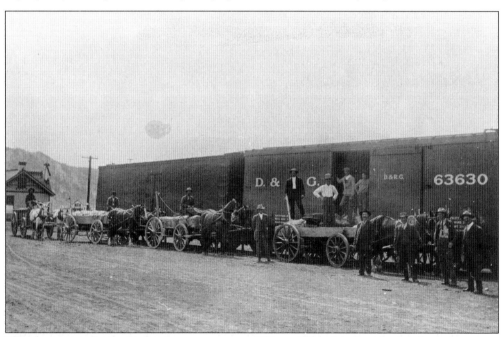

When potatoes drove the local economy, over 300 to 400 railroad carloads of potatoes were shipped from Eagle in a season. In the early half of the last century, potatoes dominated the news, economy, and lifestyle of Eagle, Brush Creek, and Gypsum. The potato boom began to fade by the 1960s, and another era faded into the sunset.

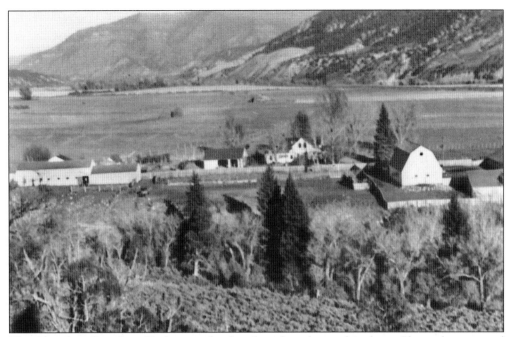

The Chambers Ranch in Eagle was a landmark with its huge white barn. Shown here around 1930, the barn faces east with the Eagle River located in the foreground below the sage-covered hills. For several years, the Chambers family operated a dairy at the ranch. In the 1980s, the barn was acquired by the Eagle County Historical Society for preservation. It now houses the Eagle County Historical Museum.

Moved to a town park near the fairgrounds, the old Chambers barn needed work. The foundation and floor were rotten. Historical society members with the help of an Eagle County construction crew and jail inmates refurbished the barn.

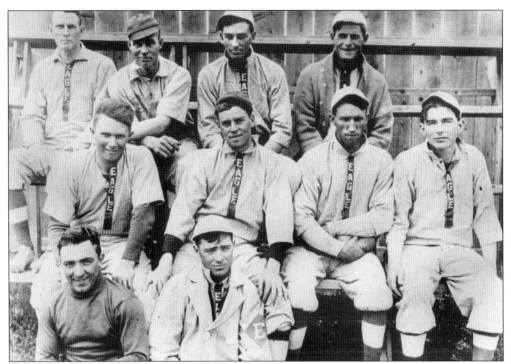

For recreation, most towns along the Eagle River had a baseball team. This Eagle team played the Denver Bears around 1914, losing in the last inning. From left to right are (first row) Mr. Place and catcher Bill Nimon; (second row) Leo Carey, an unidentified man from Minturn, Toy Dobson, and Frank Stapp; (third row) Lloyd Carey, Omar Lowland, Roy Langford, and Charley Hemberger.

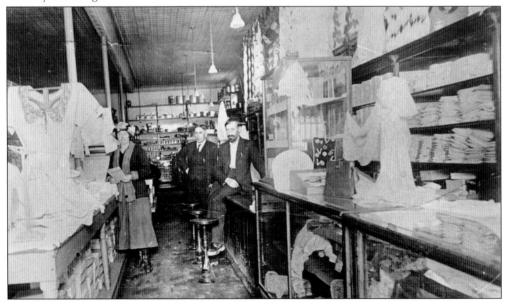

Inside the Lewis Brothers store around 1920, one could find anything from a new dress to canned goods, a butcher shop, and more. The building was erected by the Dice brothers and completed in 1912. The Lewis store closed in 1975. The building now houses a bank and offices.

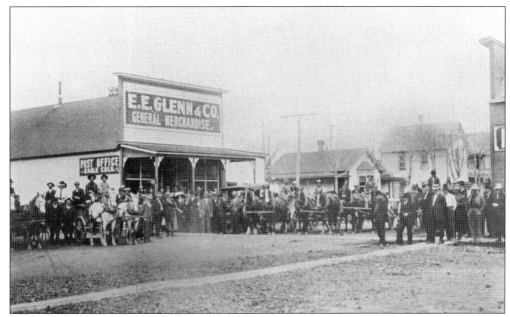

Looking northeast along Broadway Street, a large group of men on horses and wagons have stopped for a photograph. They are collected in front of the E. E. Glen and Company General Merchandise store. On the side of the building is a post office sign. The people are dressed as though for a special event.

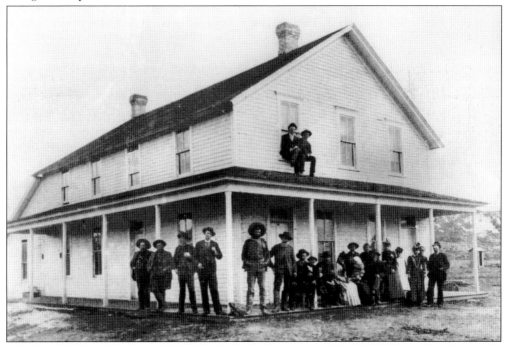

Ping's Hotel, here around 1893, overlooked the Eagle River, which is to the left in the photograph. The hotel was built by the Nogal family and had 13 rooms. At peak capacity, the Nogals had 26 boarders. In 1923, the Pings purchased the property and made several additions. The building still stands today but is slated for redevelopment.

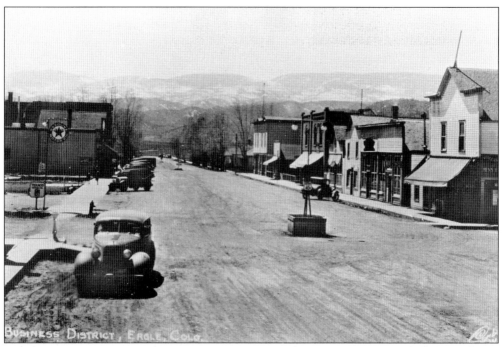

Business District, Eagle, Colo.

The Texaco station to the left was first a livery stable erected by Arthur Fulford and his brother Mont around 1890. Next the Buchholz family bought it for a stable. In 1929, the stable was torn down and the gas station built. The station remained until 1950. Next came a lumber yard, and finally the town purchased the property in the 1980s.

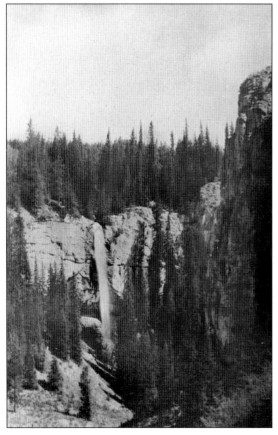

Another reason people came to Eagle valley and settled was because nature provided an abundance of beauty. This waterfall runs only in the spring. It is up Brush Creek, past Woods Lake, down Lime Creek, and off Burnt Mountain Road.

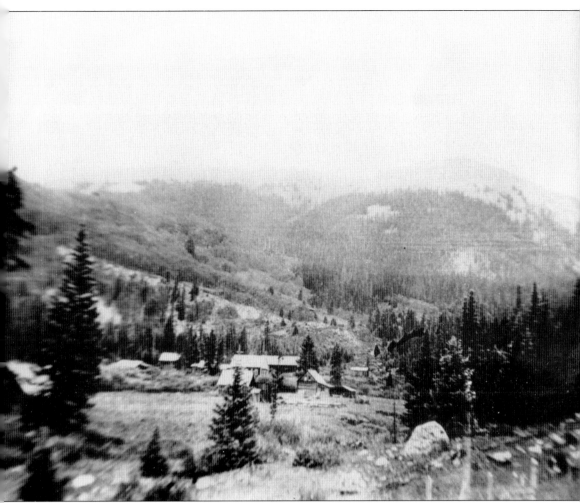

Although there is written record that some early prospectors found gold in the area of Fulford as early as 1859, it was the last mining camp to be developed. A town site was laid out in White Tail Gulch below the mines on New York Mountain. O. W. Daggett and Mr. Ennen filed for record at the courthouse on December 18, 1895, and at the time, there were 100 residents and about 25 buildings. There were two hotels, two general stores, and three saloons. At its peak, the population of Fulford reached 600 people with a third of those employed at the mines. Many of the mines were located at the top of New York Mountain, and some were dangerously dug over steep rocky inclines. In 1928, the mining town of Fulford was a quiet place. The principal metal of the area was gold and was first discovered in 1887. First called Nolan after a prospector who died when his shotgun went off while he crossed a log and severed his tongue, causing him to bleed to death, the town was renamed Fulford after Arthur Fulford's death.

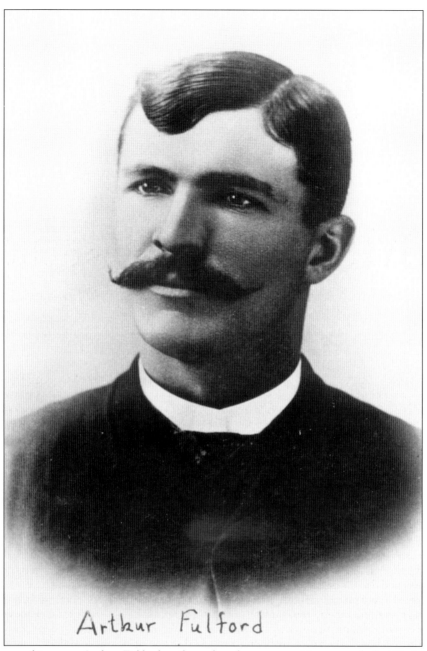

Arthur Fulford

Known as a big man, Arthur Fulford strikes a handsome pose. Once marshal of Red Cliff in 1881–1882, Arthur and his brothers moved to Eagle and were instrumental in settling the mining camp named after them. Arthur died in a snowslide on New Year's Day in 1892 on West Lake Creek. In 1859, a man named Buck Rogers and several other men prospected above Fulford. Supposedly, they discovered a fabulous mine. In the winter, Buck left his friends and went for supplies. When he came back, the mine was covered by an avalanche and so were his friends. Arthur and Mont Fulford ran a livery stable, and it is speculated that Arthur met a man who had a map to Buck's lost mine. By the winter of 1891, Arthur had possession of the map, and it is supposed he had gone there to stake a new claim and caused a massive snowslide.

Seven

GYPSUM AND DOTSERO

In 1882, when Orion W. Daggett set up his tent on a sparkling stream some four miles from where the creek meets the Eagle River, he started a new town. Across the river to the north were dry hills studded with juniper and sage, a fine place to hunt lion. However, the hills were composed of a whitish clay material called calcium sulphate—the chemical name for gypsum. The gypsum-heavy soil made for poor farming.

However, on the south side of the river, a broad valley opened up. The early explorers named this stream Gypsum Creek, and the name stuck. Before Daggett arrived on the scene, Jake Borah and his brother Alfred had tramped the Eagle Valley, supplying meat to the mining communities. While Jake's brother eventually turned to farming, Jake continued with his guiding services. By 1884, there were 31 ranches in the Gypsum Valley and a bridge was under construction across the Eagle.

Before the bridge was constructed, a ferry was used. In 1897, Daggett moved to Fulford, where he was postmaster and store operator. What those first farmers found in the Gypsum Valley was land so fertile that anything would grow. When the Ute Indians were removed from the area and the Denver and Rio Grande Railroad arrived in town in 1887, the population began to swell. The town sported a general merchandise store, blacksmith shop, saloon, livery, hotel, and a restaurant. Ranching began in earnest, and the Doll Cattle Company started a stable for racehorses.

In the early 1900s, potato farming grew just as it did in other areas and some ranchers turned to farming. Although the potato economy remained strong, it slowed considerably after World War II. It finally ended in the 1960s when the small-scale farmer could not compete with the large-scale ones. Today much of old downtown Gypsum has not been renovated. The cemetery is only a few steps away from the center of town. It still has the feel of times gone by, although new housing developments have taken the place of the cow pastures and racetrack.

O. W. Daggett followed the examples of ranchers Brett, Bowman, and Hernage by taking up a ranch in Gypsum in 1882, some five years before the railroad arrived. Rather than building a house, he staked a tent. His place would have been to the south of the Eagle River to the right of the white tents in this photograph. Besides ranching, he trapped beaver and hunted game for the Leadville markets.

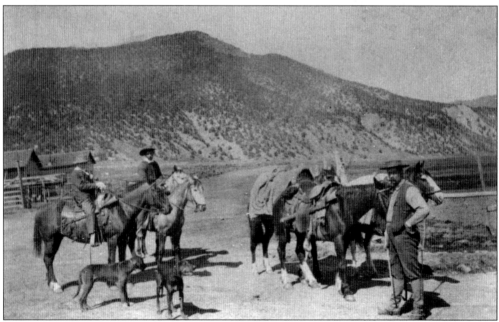

Jake Borah, arriving in Gypsum before Daggett, was a true adventurer. He was a hunter and guide in the Eagle River Valley and the Flat Tops. Jake and his wife, Minnie, ran a resort at Trapper's Lake in 1896 and at Deep Lake in 1898–1899. Here Jake stands with friends Bill Bolton Jr. (left) and A. L. Hockett (center) on horseback ready to leave with Jake (standing on right) on a guided trip.

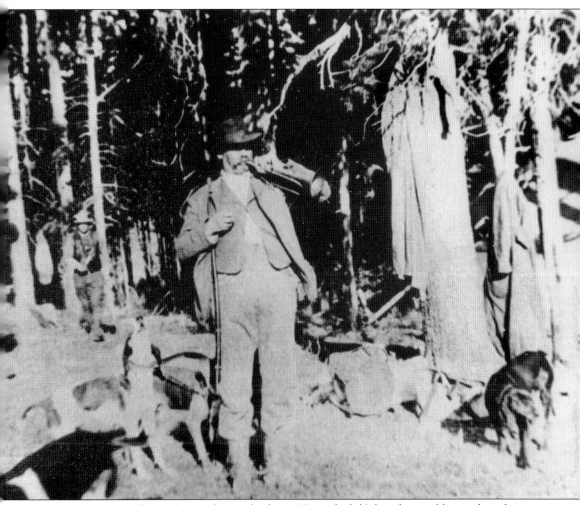

Seen here with his dogs, Jake Borah toots his horn. Not only did Jake take notable people on hunts, but he was the go-to guy for dealing with problem bears or lions. He kept fox terriers for the bear hunts and hound dogs for the lion hunts. Jake maintained and kept supplies packed and animals ready to depart at any given time because a rancher could not wait to have a lion or bear disposed of if it were raiding his stock. When Sam Doll came to the area, he and Jake became friends. Sam then convinced his brother, Frank, to come to Gypsum, and after the Doll brothers arrived in Gypsum, another chapter of life along the Eagle River was about to be written. The most famous hunt for Jake Borah was when he took Pres. Theodore Roosevelt on a two-week bear hunt in the spring of 1906. The men were unsuccessful in bagging any bears. According to legend, to cheer the president, maids at the Hotel Colorado in Glenwood Springs presented the president with a toy bear made from tufts of furry material and the term "teddy bear" was launched.

In 1888, Frank Doll holds his two prize Belgium horses, which he brought with him from Ohio on the emigrant train. Behind him is the log cabin where he and his wife, Lucy, and children, Sam and Susan, spent the fall and winter of 1887. Because the new railroad station at Gypsum did not have a platform or loading chute, a makeshift ramp of railroad ties was devised to off-load the ponderous draft horses. When one horse fell through the railroad ties, Frank believed his horse had broken a leg and would have to be destroyed. When the logs were cleared away and the horse quieted, the animal got to his feet and snorted. The injured leg was found to be bruised but not broken. A fancier of good horse flesh, Frank supplied some of the best horses in the area.

Frank Doll married Lucy Ellen Slusser (right) in 1882 in Ohio. Here she stands outside the Doll ranch house with her sister, Ada Slusser (left). Frank and Lucy had five children: Samuel, Susan, Gretchen, Frank Jr., and Dorothy. As the ranch grew, Lucy took on the job of overseeing the employees. At one time, the ranch had 82 people on the payroll, and Lucy ran the cookhouse and feeding of the men.

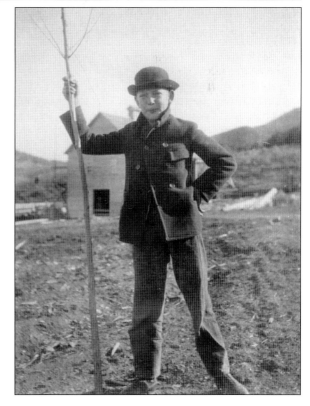

Sammy Doll, seen in this c. 1894 photograph, came on the train with his parents and sister in 1887. He was five years old when he arrived. After spending the first fall and winter in the cabin at Dotsero, the family moved to Gypsum Valley, where Frank built a house. Although a sturdy young man, Sammy came down with a respiratory illness when he was a teenager and died of the condition.

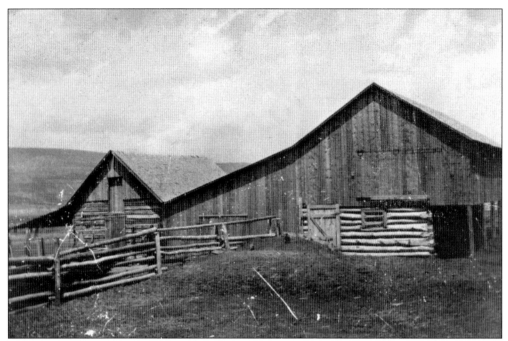

When the Doll brothers searched for land to claim in Gypsum Valley, they found springs and a flint pile from which the Ute made arrowheads. Other homesteaders believed the flint was haunted by Native American spirits and avoided it. Sam and Frank had no such reservations and placed their claim here. They built the Big Barn here and this red barn a little farther away.

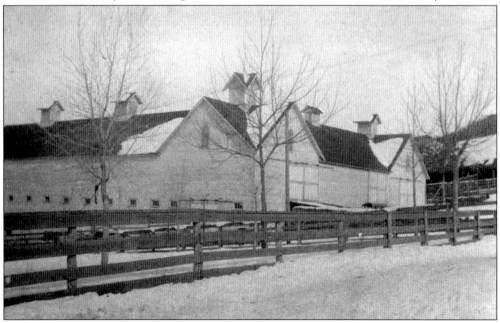

The Dolls' Big Barn was the grandest edifice in the Gypsum Valley. It had three stories. Each level had electricity and running water, and a wagon could be driven through the barn. Though it was built to hold 250 horses at its capacity, most of the time, between 40 and 50 horses were stabled inside. When Sam Doll became enchanted with horse racing, he built a racetrack at the ranch.

Mr. Stone, also called Stoney, was the livestock foreman for the Doll Brother's Ranch around 1900. Besides raising cattle, the ranch supplied work and pleasure horses to many people in the area. On Sunday afternoons, people arrived by wagons with picnic lunches to enjoy the races put on at the Doll brothers' racetrack.

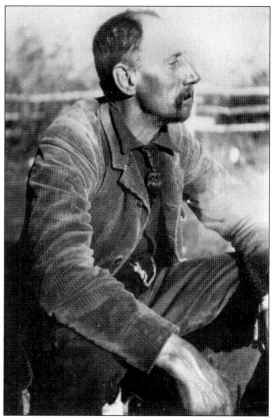

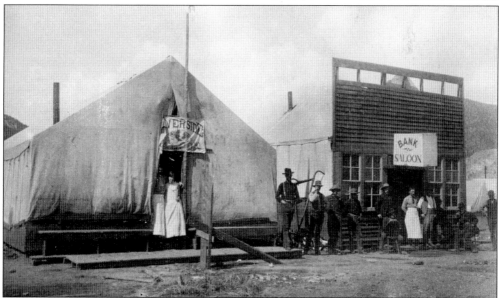

Because Gypsum was of a lower elevation than the towns on the upper section of the Eagle River, the climate was mild. Snow melted in late February, and the growing season was longer. Water was plentiful from Gypsum Creek. Early settlers built irrigation ditches to take water where it was needed. The town had every reason to grow and prosper.

The Doll brothers built the flour mill around 1900. A three-story building, the mill was powered by water. Considered modern in its time, the mill ground all wheat produced in the area, putting out 80 barrels a day. The mill even imported wheat to grind. After the mill burned, suspicion followed that the fire had been deliberately set by disgruntled businessmen in the area.

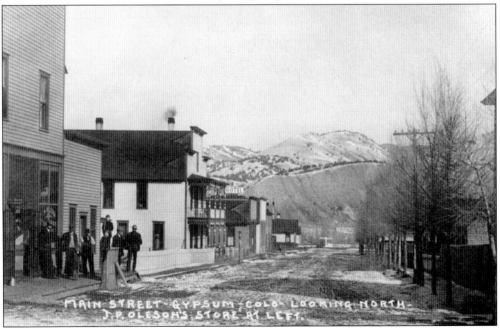

In the early 1900s, the town of Gypsum had grown. In this photograph of First Street, the tents of the early town had given way to one- and two-story buildings. At the end of the photograph, the train depot can be seen. Those ranchers who settled in the Gypsum Valley found the ground was so fertile that anything they grew or raised thrived.

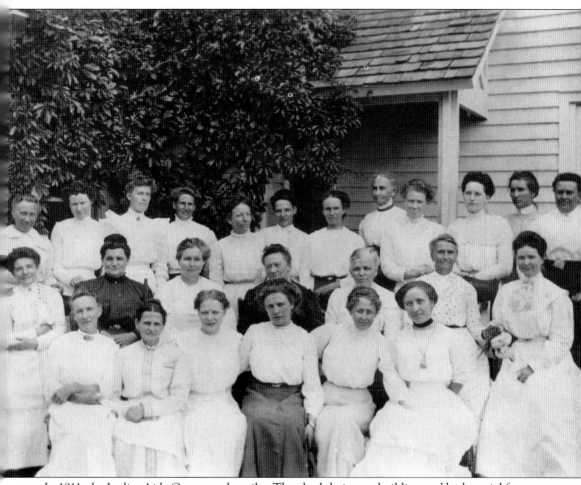

In 1911, the Ladies Aide Group made quilts. They had their own building and had special frames made for the quilts in progress. Once in the frame, the quilt could be worked on three sides. At the end of the day, the hinged frame was stored upright against the wall. Included in this picture are Mrs. Hugh Chatfield, Lucy Doll, Gretchen Doll Defore, Mayme Stremme Price, Ada Schlusser, Ella Gannon, Mrs. Schliff, Kitty Heyer, Mrs. Packard, Mrs. Norgaard, Mrs. Theadore Stremme, Mrs. Greene, Mrs. Liver, Mrs. Jensen, Daisy Harrison, Mrs. J. P. Oleson, Mrs. Sam Oleson, Raye Staup Kroll, Susan Doll, Bird Hockett, Sena Ulin, Julia Heyer McGlochlin, Alice Lea, and Sophie Ryden.

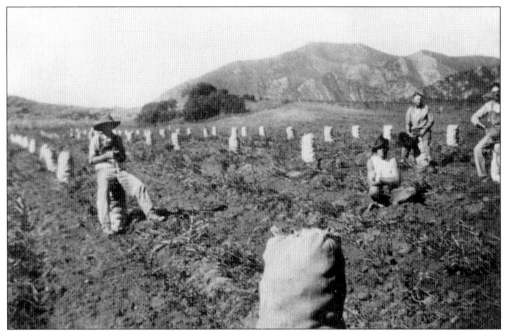

Just as the other communities found, when the mineral rush ended, farming became the income producer for the area. Gypsum farmers planted potatoes, and they harvested huge crops. On the Bobson Ranch along Gypsum Creek around 1940, the potato harvest is in full swing. Today you can drive along Daggett's ditch near the creek and see an old potato sorter.

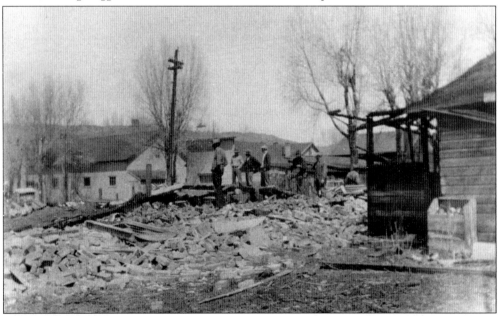

On Monday, April 25, 1932, about 4:00 a.m., the Bonar Poll Hall exploded. All four walls of the hall were blown outward and the building left in flames. Mr. Bonar carried $1,800 in insurance on the building, and it was later determined the cause of the fire was arson. Mr. Bonar spent time in jail for the act. With this building gone, it was the end of friendly poker games in the back room.

This photograph of the Eagle County High School in Gypsum shows the early construction of the school in 1910. The school is gated with one gate for pedestrians and the other gate accessible for wagons. In 1919, Helen Harries Doll was the schoolteacher.

In 1910, the first class of Eagle County High School in Gypsum graduated. Shown from left to right are (first row) Pearl Chatfield, Elizabeth Quinlan, and Ray Staup; (second row) teacher H. P. Mower, Carl Norgaard, Aden Mosher, Arthur Stremme, and Harold Norgaard. Pearl Chatfield became Mrs. Jensen, and Elizabeth Quinlan became Mrs. Bedell.

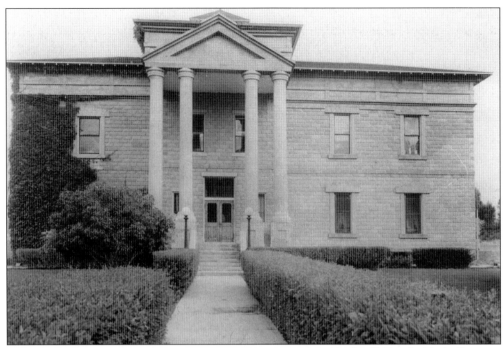

By the 1930s, the Eagle County High School had undergone some renovations. The original chimneys are gone, as is the bell tower, and the two large spruce trees in the front of the building have been removed. Tall columns have been added to the front and the building expanded. Gone are the gates, and a manicured hedge is now in place.

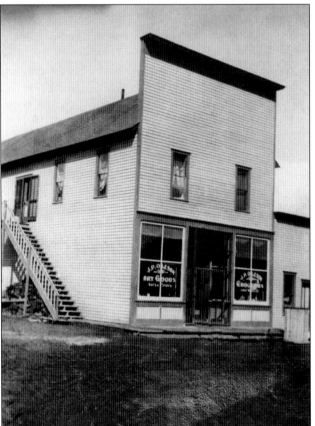

The J. P. Oleson Store in Gypsum was a two-story building with a fake facade to give it more height. Oleson turned the small building to the right into a bank. Those who wanted to could get a haircut in the bank. The sign in the downstairs windows reads: "J. P. Oleson Dry Goods, Hats & Shoes" and "J. P. Oleson Groceries."

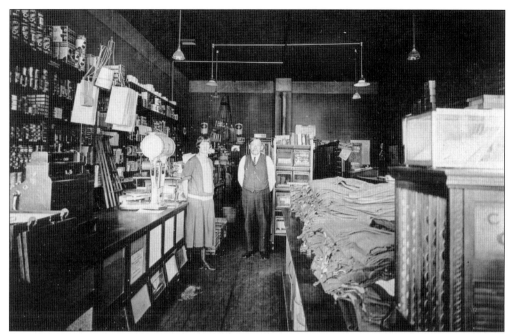

Another store that provided goods to the growing community in Gypsum was Stremme's Store and Post Office. Seen in this picture in the 1920s are Theodore Stremme and his clerk, Thelma Anderson Wilson. Canned goods are lined up on the shelves and work pants piled on tables in the middle of the room. Drop lighting fixtures are arranged throughout the store.

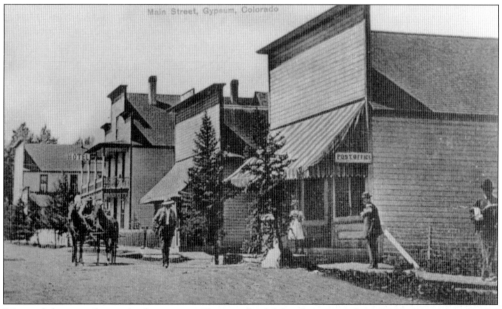

Most of the storefronts in downtown Gypsum had false fronts on the upper story to create the look of a bigger building. As seen here in a photograph in 1905, the building in the foreground even had an awning. There were boardwalks to provide relief from the mud and animal dung, which could plague a street.

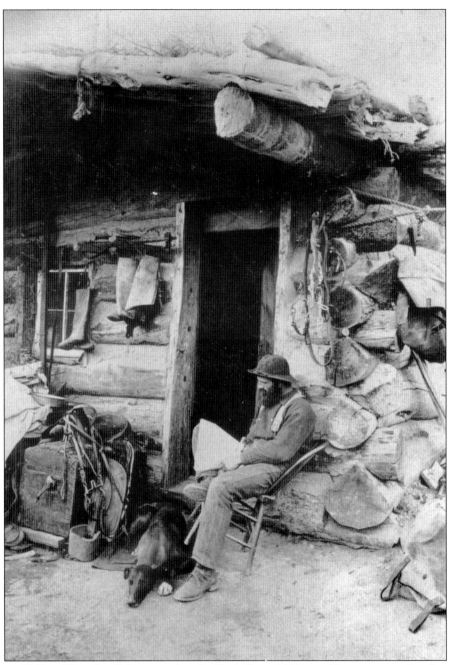

Born in 1848 in Ohio, Jim Dilts arrived in the Eagle River Valley and became one of its foremost citizens. He established the Deep Creek Ranch, which he later sold to Frank Doll. After teaching school for several years, he was elected county superintendent in 1896 and held the office for six years. Having studied law at Boston University, he next practiced law and served as county attorney for many years. After serving Eagle County as attorney, he was elected to the state legislature for two terms, and he served the area until his health failed him in 1924. In this photograph, Jim is seated outside of his cabin on Deep Creek and hardly looks like the highly educated, prosperous, dedicated man that he was.

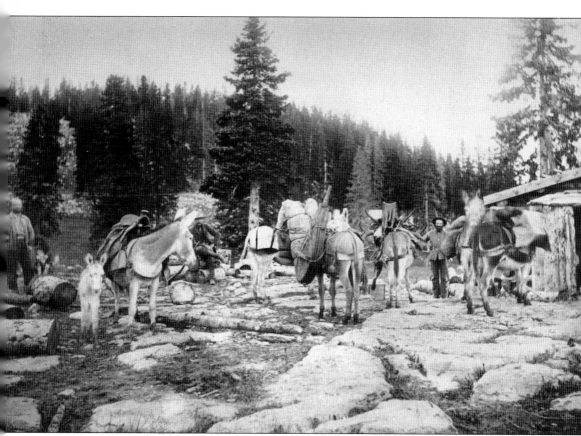

After the Eagle River passes by Gypsum Creek, it flows in a broad channel through a sagebrush-covered valley until it meets the mighty Colorado River at Dotsero. Just upstream from Dotsero was a place called Carbonate, where minerals were first found in the area. During the silver rush, prospectors found trace minerals at Carbonate. This was discovered late in the fall. More than 1,000 hopeful miners camped at Dotsero with hopes of an early spring so they could make their way back to Carbonate. As it turned out, the spring was late, and the snow continued to fall. Some men left when it seemed spring would never come. When those who did stay returned to Carbonate, they found little mineral returns for their effort. In this *c.* 1900 photograph, Mr. Johnson, Frank Doll, and James Dilts have loaded old mining equipment from the area and are ready to take it out.

Approximately 20 percent of Colorado's land surface is covered by volcanic rocks of Cenozonic age. Colorado also has evidence of some of the largest single eruptions in all of geologic history. Gypsum has its own Holocene volcano. Currently the volcano at Dotsero is the only active volcano in Colorado. The most recent eruptions produced an explosion crater, lahars, and substantial lava flow. A small maar and scoria cone complex erupted on the north side of the Eagle River about 4,150 years ago. The Dotsero crater is 700 meters wide and 400 meters deep. When it last erupted, it left a broad area of lava that stretches all the way to the Colorado River. Shown here around 1900 is the lava bed near Dotsero. With the Eagle River making its end here at the Colorado River, it has dropped almost 8,000 feet in elevation.

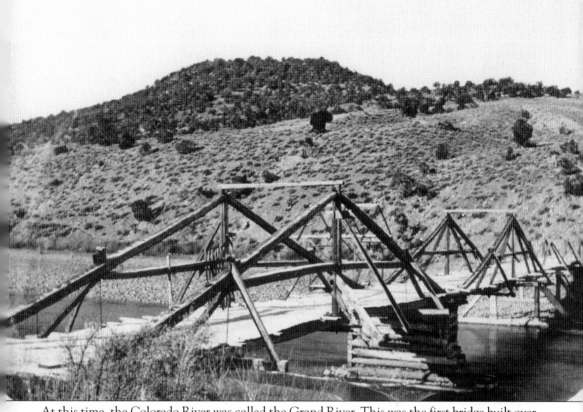

At this time, the Colorado River was called the Grand River. This was the first bridge built over the river in about 1887 at Dotsero. Many people believe the name Dotsero came from the railroad marking the spot on a map, but the name was in existence before the railroad appeared. However, when the spur to Bond was completed, it terminated at Orestod, or Dotsero spelled backwards. From this point, the Colorado River flows westward. It travels through Utah and Arizona before meeting the Gulf of California near Baja. Just as it is true about the water diversions in the mountains east of the Colorado River, fortunes are made from the water flowing in the Colorado River. Millions of people depend on the electricity it produces and also the moisture it brings to the farmers along its course.

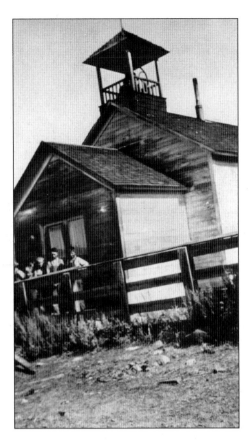

Children line up against the railing of the Dotsero School. With the railroad building a line through Glenwood Canyon and next the highway being completed through the rock walls of the majestic canyon, workers were needed to complete the tasks. Before the Dotsero Cutoff was completed, cattle were loaded and unloaded at Dotsero to move up the Colorado River to the ranches located there.

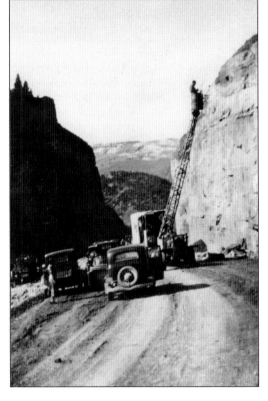

Although this photograph is not along the Eagle River, it is important because of the road that was built through Glenwood Canyon. Even the Ute preferred to travel around the canyon, rather than through it. Once the road was finished, it opened western Colorado to travelers on the eastern slope.

The Eagle River ends when it flows into the Colorado River. However, the life of a river never ends. The river has provided steam for locomotives, mills for mining, and irrigation for crops. The river is a source of recreation for fishermen and rafters and for snow making for skiers. Every day, it is the essence of beauty. The first explorers who came to the Rocky Mountains were mountain men who trapped beaver for the fashionable silk hats coveted on the Eastern Seaboard. Although there is little evidence of mountain men in the Eagle River Valley, the men who came, such as Jake Borah, explored the rivers and valleys and found deer and elk in the meadows, lions and bears in the forest, and fish and beaver in the rivers. For generations, the river remains the same. Here along Lake Creek where it joins the Eagle River just below the Frenchman's Ranch, beavers are once again at work.

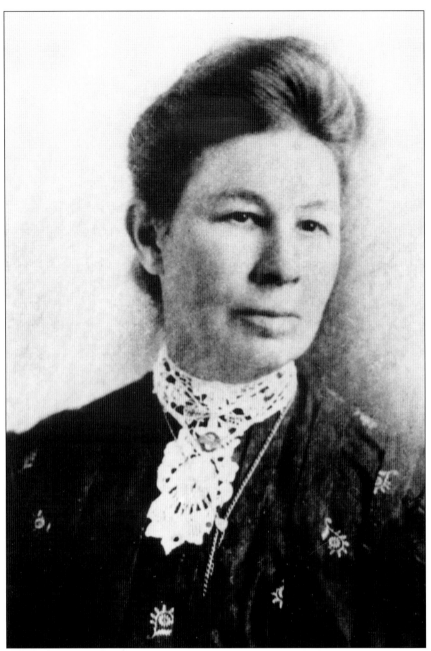

Ida Herwick was one of the first settlers along the Eagle River. For many years of her life, Ida resettled from Avon, to Wolcott, to Eagle, living in log cabins and dugouts. Ida wed Josiah Lafayette Herwick. Their son, Fred, was the first child born in Eagle County. William Nottingham purchased Herwick's filing in Avon. After living in crude facilities and moving often while raising a large brood of children, Josiah bought four lots at Third and Howard Streets in Eagle, and Fred built Ida a house. By October 1899, Ida moved into her own home. Probably no other woman lived in so many different places along the Eagle River at such an early time. She called the Eagle River Valley home. Since Ida's time, many others have discovered the allure of the river, the verdant valleys, and the pristine mountain trails. They also call it home.

BIBLIOGRAPHY

Burnett, William W. *The Eagle on Battle Mountain at Gilman, Colorado and My Life as I Remember.* Eagle, CO: Eagle Valley Library District, 2002.

Knight, MacDonald, and Leonard Hammock. *Early Days on the Eagle.* Eagle, CO: Self-published, 1965.

Mehls, Steven F. *The Valley of Opportunity.* Denver: Bureau of Land Management, 1982.

Seibert, Peter W. *Vail: Triumph of a Dream.* Boulder, CO: Mountain Sports Press, 2000.

Simonton, June. *Vail.* Dallas: Taylor Publishing Company, 1987.

Wolle, Muriel Sibell. *Stampede to Timberline: The Ghost Towns and Mining Camps of Colorado.* Chicago: Swallow Press, 1974.

ACROSS AMERICA, PEOPLE ARE DISCOVERING SOMETHING WONDERFUL. *THEIR HERITAGE.*

Arcadia Publishing is the leading local history publisher in the United States. With more than 4,000 titles in print and hundreds of new titles released every year, Arcadia has extensive specialized experience chronicling the history of communities and celebrating America's hidden stories, bringing to life the people, places, and events from the past. To discover the history of other communities across the nation, please visit:

www.arcadiapublishing.com

Customized search tools allow you to find regional history books about the town where you grew up, the cities where your friends and family live, the town where your parents met, or even that retirement spot you've been dreaming about.